PRACTICAL COURSE IN
WATERCOLORS

Fig.1 José M. Parramón. Copy of *Venice, San Giorgio from the Dogana*. Artist's collection. At the end of the book you will find instructions on how to copy this famous Turner watercolor, a task that requires great attention and patience. Here you can see a small detail of the final result.

Fig. 2. Tomás Sayol. *Landscape*. Collection of the Catalan Watercolorist Society. The late Tomás Sayol was a great watercolor painter, a painter of simple and great subjects, who always painted from Nature. There is a huge contrast created between the vast, dark mountain face and the little bright houses at its foot.

PRACTICAL COURSE IN
WATERCOLORS
COMPOSITION & INTERPRETATION

JOSÉ M. PARRAMÓN

Fig. 3. José M. Parramón. *Fishermen's dock in Barcelona.* **Artist's collection. This is a good example of contrast and atmosphere, with the reflections and boats in the foreground, very solid in both form and color, and the background, diffused and grayish, emphasizing three dimensions, a factor that is discussed later in the book.**

General Director: José M. Parramón Vilasaló
Texts: José M. Parramón
Editing, layout and dummy: José M. Parramón
Cover: J. Gaspar Romero and José M. Parramón
Translation from the Spanish: Monica Krüger

Photochromes and phototypesetting: Novasis, S.A.L.
Photography: Studio Orofoto

1st Edition: February 2000
© José M. Parramón Vilasaló
© Exclusive edition rights: Ediciones Lema S.L.
Edited and distributed by Ediciones Lema S.L.
Gran Via de les Corts Catalanes, 8-10, 1.st 5.th A
08902 L'Hospitalet de Llobregat (Barcelona)

ISBN 84-89730-87-3

Printed in Spain

Table of Contents

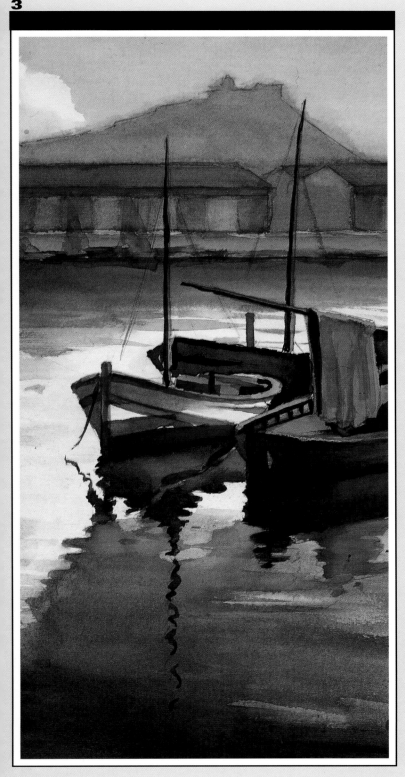

3

4

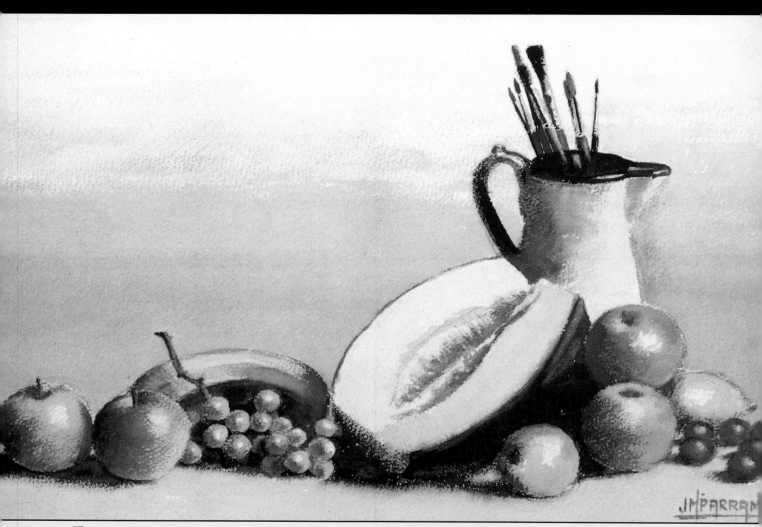

5

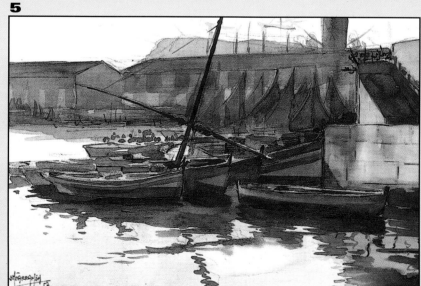

Fig. 4. José M. Parramón. *Still life with brushes and fruit.* Artist's collection. I painted this on textured Whatman watercolor paper using the dry brush technique, which is to say, sweeping the brush to create the diffused, toned down grays. Notice that this technique has two different methods: one is to drag a dry paintbrush loaded with diluted paint across the paper creating a watercolor wash, and the other being, to drag an almost dry brush loaded with thick paint across the paper.
You can see the dry brush technique has been used to paint the fruit, jug and brushes whereas a water-color wash can be seen in the diffused gray of the background.

Fig. 5. José M. Parramón. *Fishermen's wharf in Barcelona.* Artist's collection. Wharf are always a suitable subject to paint especially if, as is the case here, they are a popular place for fishermen to leave their boats.

Introduction

In this volume, as well as discussing the art of composition and interpretation, we will be revising the fundamental basics of perspective, a subject that is dealt with in *Practical Course in Watercolors*. **Van Gogh**, in one of the many letters to his brother Théo, expressed his thoughts on the purpose of perspective:

"There are laws of proportion, light and shade, and of perspective, all of which must be understood in order to paint. If you are ignorant of these laws the battle is always futile and success is unachievable".

Van Gogh had a good point; it's not possible to leave perspective aside, if we bear in mind, as I'll go on to tell you later in this book, that perspective is one of the basic factors in creating three dimensions, and that you and I only work with two dimensions: the length and width of the paper. However we will come back to this later, reminding ourselves that perspective is necessary to paint houses, streets, interiors, cubes, cylinders, flasks, bottles, books, and in still lifes. It is also necessary to resolve the divisions of space and depth when we draw or paint tiled floors, mosaics, rows of trees, the pillars in a cloister or those of a classical building.

However, before we approach the basic subject of composition and interpretation, let us talk a little about what and where to paint. I would advise you to visit museums and exhibitions and to look in books at reproductions of paintings that the Great Masters did, while reminding ourselves of the historian **Wölfflin**, who said:

"A painting owes more to other paintings than to the observation of nature".

On page 42 we shall begin to treat this subject, analyzing first, the formulas of the art of composition as dictated by the Greek philosopher **Plato** and the law of the golden section set out by fellow Greek mathematician **Euclid**. After, I will talk about how to apply the ideas of **Plato** and Euclid and what rules are used to determine and emphasize both depth and three dimensions. Finally I shall suggest a series of practical exercises on composition and interpretation, that are emphasized in painting a copy of the famous **Turner** watercolor, *Venice, San Giorgio from the Dogana*. I hope that you enjoy, as I did, painting step-by-step this famous **Turner** watercolor.

José M. Parramón

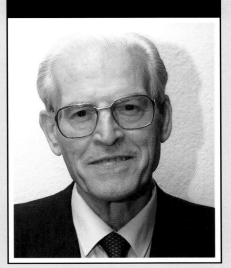

Fig. 6. José M. Parramón, author of the collection, *Practical Course in Watercolors*, comprising of five volumes, and author of forty books written on teaching drawing and painting. His books have been translated and published in more than fifteen countries including America, Japan and Russia.

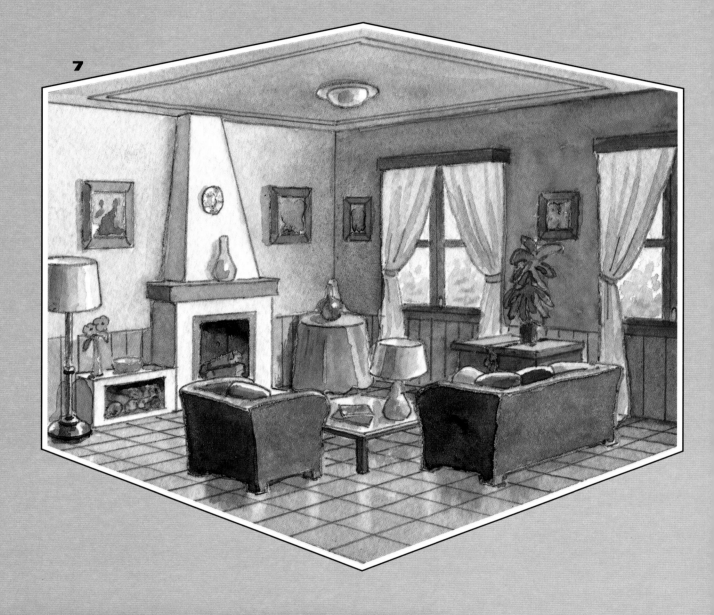

7

Fig. 7. An example of oblique perspective, two vanishing points, used in the drawing of this room with a chimney and two windows, where it defines the perspective of the square, rectangle, cube, rectangle prism, circle and tiled areas. The knowledge of perspective is necessary in the drawing and painting of interiors, urban landscapes and objects in general (cars, boxes, houses, mosaics, etc.).

PERSPECTIVE

In the following pages we are going to summarize the
background of perspective; it's a short story, very short,
so that you can get an idea of when, how and who the artists
were that first developed the knowledge of the laws
of perspective, a subject dealt with in this book, a subject so
basic in the painting of urban landscapes and interiors that we
can't omit it. But wait, before introducing the architects
Brunelleschi and **Alberti** and the painters **Masaccio** and **Viator**,
I want to talk to you about the fundamentals of perspective,
so that you will be familiar with the techniques that these artists
from the 14th and 15th centuries started to use.

Fundamentals of Perspective

Well it's almost certain that you already know the fundamentals of perspective, however just to be sure and to refresh your memory we will go over them one more time, including a revision of the following basic principles. The first of these principles is:

the horizon line (HL).

This is the imaginary line that is straight in front of us, looking ahead and at eye level. The best way to demonstrate this line is to look at the sea, focusing on the line that divides the sea and the sky, noticing that it rises and falls according to where you are positioned, if you are standing, sitting on the sand or viewing from a rock above (figs. 8, 9 and 10). Remember then, that the horizon line may be above or below the subject that you are drawing or painting (fig. 11 and 12, opposite page). Finally, the horizon line can be within the picture or outside of the picture, as though you were looking from a bird's eye view, i. e. a view from high up or a raised point (fig. 13, opposite page).

The second principle is:

the vanishing points (VP).

Remember that the number of vanishing points relates to the type of perspective. There are three types of perspective:

Parallel perspective
only one vanishing point.
Oblique perspective
two vanishing points.
Aerial perspective
three vanishing points.

The most common image used to demonstrate parallel perspective is that of straight train tracks like those you can see in the photograph I have taken in figure 14 (opposite page). Finally, looking at the diagram figure 15 (opposite. page) you can see three cubes in perspective: cube A: parallel perspective with only one vanishing point; cube B, oblique perspective with two vanishing points and cube C, aerial perspective with three vanishing points.

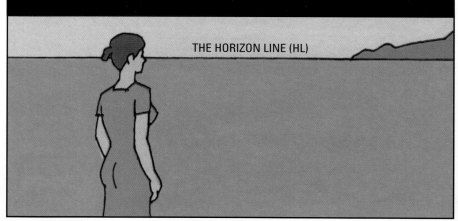

8

THE HORIZON LINE (HL)

9

10

Figs. 8, 9 and 10. The horizon line (HL) is situated in front of us, looking straight ahead and at eye level. It's an imaginary line that becomes physical when staring at the sea, the line where the sea and sky are divided, which rises and falls in accordance to whether we are looking from a standing position on the beach (fig. 8), sitting (fig. 9) or from a mound or raised area (fig. 10). It is the line that joins all vanishing points, be it parallel perspective, with only one vanishing point; oblique perspective, with two vanishing points or aerial perspective, with three vanishing points. The diagonal vanishing points also coincide with the horizon line, this being something that we shall be discussing later in the chapter.

Figs. 11, 12 and 13 (opposite page, top). Take into account that the horizon line can be below or above the subject, as you can see in figure 11 and 12, and also remember, that the horizon line can be inside or outside of the picture, as in figure 13, where the artist views his subject from a bird's eye point of view with the horizon line outside of the picture.

Fig. 14 (opposite page, top right). Here is a typical example of parallel perspective, given using the straight rails of a train track. See how the tracks join together at the horizon line, along with its one vanishing point, joining at exactly the same point, this is a unique occurrence which can only be demonstrated using this example.

11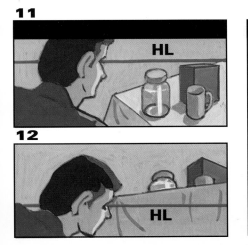

HL

12

HL

13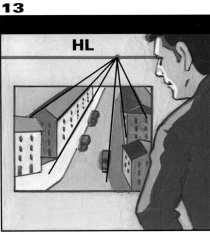

HL

14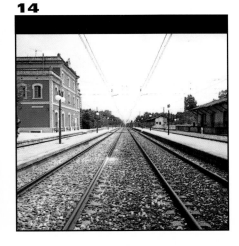

VP

VP HL

VP

VP

15

B

A

C

Fig. 15. These are the three different types of perspective, used here on the drawing of a cube: in A, the cube is drawn in parallel perspective, with only one vanishing point; in B, the cube is drawn in oblique perspective, with two vanishing points, and in C, the cube has been drawn in aerial perspective, with three vanishing points.

15A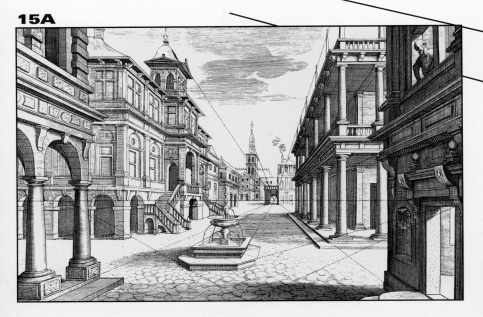

Fig. 15A. Hans Vredeman. *Perspective.* In 1599 the Dutchman Vredeman published his infamous book on perspective, consisting only of illustrations, no texts, with images and examples of both parallel and oblique perspective.

More on The Fundamentals of Perspective

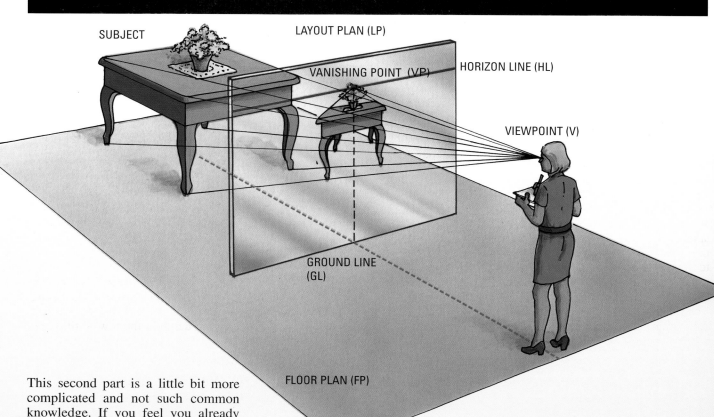

SUBJECT

LAYOUT PLAN (LP)

VANISHING POINT (VP)

HORIZON LINE (HL)

VIEWPOINT (V)

GROUND LINE (GL)

FLOOR PLAN (FP)

This second part is a little bit more complicated and not such common knowledge. If you feel you already remember this part then skip page 14, but I must insist there is nothing like a quick lesson to refresh your memory. Let's start by looking at figure 16 where, *the elements are reproduced by a placed object, seen and drawn in perspective.* Take note: the artist is directly in front of the subject, looking straight ahead, using parallel perspective, with only one vanishing point. Between the artist and the subject, the artist has imagined a transparent surface: *this is the layout plan (LP)*, that corresponds with the size and proportion of the artist's drawing paper or canvas. As we will see in the coming pages, it was the celebrated 15th century architect **Alberti**, who discovered this principle of the layout plan, which he called the *veil of the painting.* **Leonardo da Vinci** transformed Alberti's veil into the image of the *window*, an aperture which, like

that of the layout plan or veil, captured the scene being drawn or painted. At eye level and looking straight ahead, the artist decides and plans the *horizon line (HL)* of the drawing, the line printed in red in the diagram. You will see that the *vanishing point (VP)* is in the center of this line, only one point that in this case coincides with the *viewpoint (V)*, at the eye level of the artist. This circumstance, with a coinciding vanishing point and viewpoint, is only seen in that of *parallel perspective of only one vanishing point.*

Look now, at the foot of the layout plan, at the ground line (GL), indicated with a dotted red line. The ground line is a principle that we use to divide the space to create depth (for example, the distance between one

Fig. 16. Diagram of the principles that control the reproduction of a subject seen and drawn in perspective. The artist places him or herself before the subject and imagines a space in front, that is in exact proportion to the size of his or her drawing paper, which in terms of perspective, is the picture's layout plan (LP). Draw the horizon line (HL) –red line– and place the one vanishing point (VP) (now you are working with parallel perspective which has only one vanishing point), which is at the same point as the viewpoint (V). Last, check the existence of the floor plan (FP) and the ground line (GL), this last line is used for dividing the space to create depth, which we will look at later.

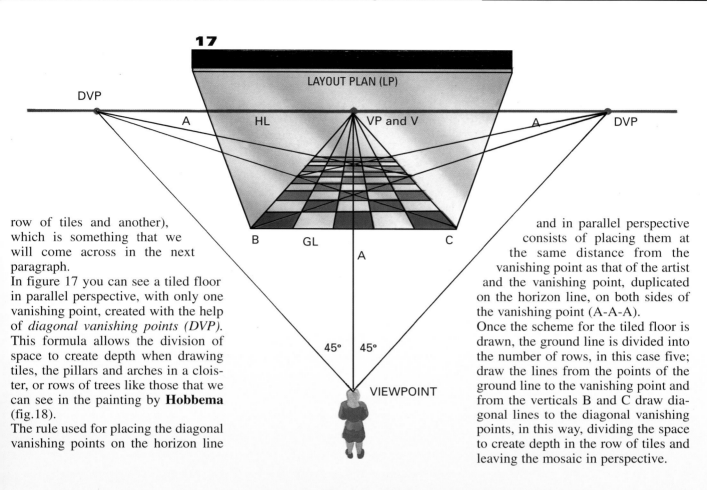

17

LAYOUT PLAN (LP)

DVP

A HL VP and V A DVP

B GL C

A

45° 45°

VIEWPOINT

row of tiles and another), which is something that we will come across in the next paragraph.

In figure 17 you can see a tiled floor in parallel perspective, with only one vanishing point, created with the help of *diagonal vanishing points (DVP)*. This formula allows the division of space to create depth when drawing tiles, the pillars and arches in a cloister, or rows of trees like those that we can see in the painting by **Hobbema** (fig.18).

The rule used for placing the diagonal vanishing points on the horizon line and in parallel perspective consists of placing them at the same distance from the vanishing point as that of the artist and the vanishing point, duplicated on the horizon line, on both sides of the vanishing point (A-A-A).

Once the scheme for the tiled floor is drawn, the ground line is divided into the number of rows, in this case five; draw the lines from the points of the ground line to the vanishing point and from the verticals B and C draw diagonal lines to the diagonal vanishing points, in this way, dividing the space to create depth in the row of tiles and leaving the mosaic in perspective.

Fig. 17. Diagram of the diagonal vanishing points. This formula permits the division of space creating depth and perspective, like the distance between a row of tiles in a **mosaic, the distance between the tracks of a train or a row of trees, like those in the painting by the Dutch painter Hobbema (fig. 18).**

18

Fig. 18. Meindert Hobbema. *The avenue at Middelharnis***, National Gallery, London. Due to its original concept, this is one of Hobbema's most famous landscapes, with the traditional formula of the Dutch landscape painters of emphasising the sky, but in this case breaking up the sky with two rows of trees in perspective. This painting by Hobbema had a considerable influence on the English landscape artists of the 18th and 19th centuries.**

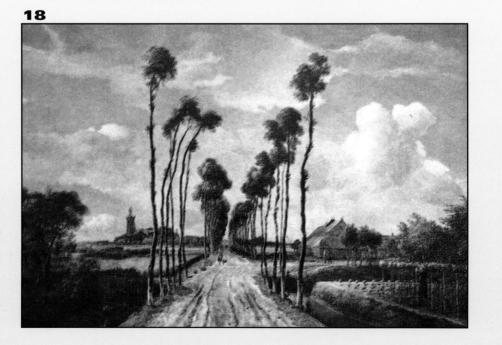

The Forefathers of Perspective

According to the painter **Giorgio Vasari**, noted for his books *The Lives of the Best Italian Architects, Painters and Sculptors*, published in Florence in 1568, the architect and painter **Brunelleschi** *"...spent a lot of time studying perspective, discovering a perfect method, consisting of the representation of the floor and the upper section and, by means of intersecting lines, drawing the building in perfect perspective"*. (fig. 23, opposite page).

But, dissatisfied with this method, Brunelleschi carried out an experiment that determined the viewpoint and the vanishing point of parallel perspective, that was only missing the horizon line to be the same as our actual parallel perspective.

Antonello Manetti, biographer of Brunelleschi explains it like this:

"On a square panel of about 30 cm he painted the Baptistery of San Giovanni, viewed from the entrance of Santa Maria del Fiore, the Cathedral of Florence. He added a layer of burnished silver to the sky in the image, so that the real sky and the clouds would be reflected. He made a hole in the center of the painting, about the size of a lentil, on the painted side, which was then widened from behind into the shape of a cone until it was the diametre of a small coin. He signaled to those who wanted to see, that they look through hole, using its larger side, while at the same time, using one hand to hold the painting and the other to hold a mirror up at eye level, in such a way that the painting is reflected in the mirror (fig. 21 and 22), that which, the spectator believed to be the real scene".

Art history points to three artists as the creators of Renaissance Art: Brunelleschi the architect (also a notable sculptor and painter), **Donatello** the sculptor, and **Masaccio** the painter. They were good friends that often met, according to Vasari, because *«they enjoyed eachothers company, being able to chat and discuss the problems that they had with their art»*. During this time Masaccio painted the celebrated mural *The Trinity* (figs. 19 and 20), famous for its ambitious perspective, collaborating on its design with his friend Brunelleschi.

19

20

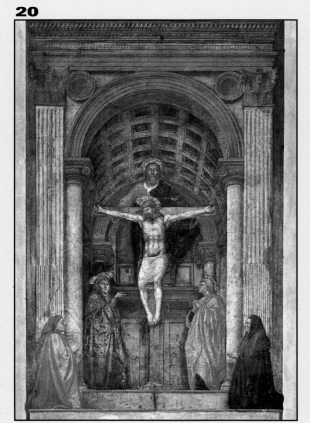

21

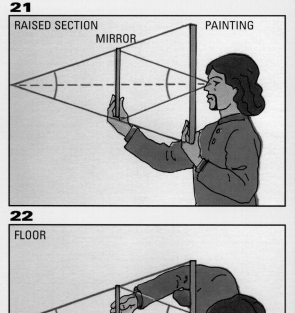

RAISED SECTION PAINTING
MIRROR

22

FLOOR

23

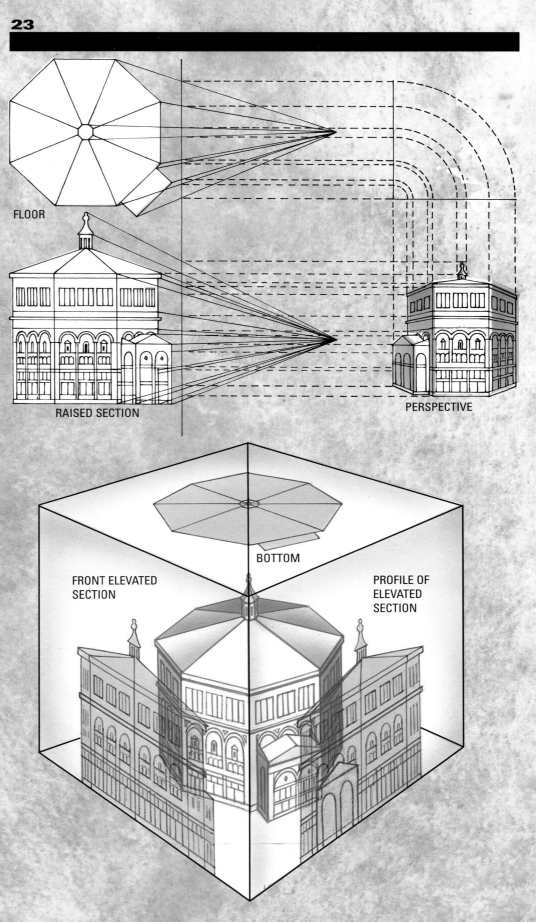

FLOOR

RAISED SECTION

PERSPECTIVE

BOTTOM

FRONT ELEVATED
SECTION

PROFILE OF
ELEVATED
SECTION

Figs. 19 and 20 (opposite page, right and centre). Masaccio. *The Trinity*. **The Church of Santa Maria Novella in Florence. Considered the painting most representative of the beginning of the Renaissannce period,** *The Trinity,* **was painted by Masaccio with the technical help and advice of Brunelleschi, particularly in the resolution of the dome, the perspective of which was greatly admired by the artists of that era.**

Figs. 21 and 22 (opposite page, left). Taken as a model of the Baptistry (see this page), viewed from the entrance of the cathedral in Florence, Brunelleschi painted a panel and made a hole in the centre of the painting, viewing the painting from its reflection in a mirror, as you can see demonstrated in the diagram, surprising those who looked through at this reflection, by its extraordinary realism.

Fig. 23. The architect and painter Filippo Brunelleschi discovered an ingenious system of a drawing, seen in the diagram, *floor* , **and another of the same building seen in the diagram,** *raised section,* **that with the intersection of parallel lines, a drawing can be drawn in perspective.**

The Forefathers: Leon Battista Alberti

The architect **Alberti**, was a learned composer of music, painter and writer, who in 1436 wrote *Della pittura*, the first book ever written on the history of perspective which he dedicated to his friend Brunelleschi. In his book, after stating that the artist should view the subject through a veil (like our layout plan, explained and illustrated on page 12), Alberti invented a formula to automatically determine *the distance between bodies or forms that are repeated in the depth of a painting*. It's a formula very similar to that of our *diagonal vanishing points* that we saw on page 13, which you can verify by looking at the following diagrams and texts (figs.24, 25, 26, and 27).

Fig. 24. Brunelleschi like Alberti and all the other artists of their time, always worked in parallel perspective, that of only one vanishing point, but he never mentioned in his studies the horizon line or where he was positioned, *looking straight ahead, at eye level.* But what Brunelleschi, Alberti and all the other artists did do was to place the vanishing point at the height of a person, with and without knowing it, they created the horizon line.

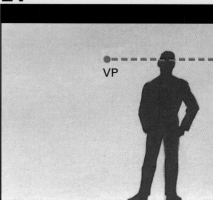

24

25

26

27

Fig. 25. To solve the problem of drawing a tiled floor, Alberti placed the vanishing point in the center labelled of the picture, dividing the base of the mosaic into five rows (labelled: A, B, C, etc.) and drawing the parallel vanishing lines, duplicating the space of the mosaic (A-A) and raising the mosaic on the right hand side forming a *raised veil plan or layout plan (LP) profile*. Situated finally, in the second A space, on the right, the *viewpoint (V)*.

Figs. 26 and 27. Next, from the viewpoint (V) he drew five diagonal lines (blue lines) taken from the base of the mosaic (points A, B, C, etc.) crossing through the layout plan (LP) or veil determining the distance, depth and perspective of the rows.

VP

VEIL OR LAYOUT PLAN (LP) PROFILE VIEW

A B C D E F

VP A A V

VP V

LP

A B C D E F

VP V

LP

Jean Pèlerin, Viator

Nearly seventy years passed and, because perspective had become an obsession among the majority of artists, drawings were executed with just one vanishing point. Artists were unaware of the horizon line and worked exclusively with the rules of parallel perspective that Alberti had invented. The treatises made on Alberti's rules of parallel perspective are some of the most impressive masterpieces of Renaissance art by **Paolo Uccello, Piero della Francesca, Carlo Crivelli** (fig. 28), **Leonardo da Vinci** (fig. 29) and **Albrecht Dürer** (fig. 30). The aforementioned **Uccello** practically stopped painting altogether in order to continue his studies of perspective. Nothing changed until 1505, when a **Jean Pèlerin** also known as *Viator* (the traveller), Canon of Toul Cathedral in France, published a book called *De artificialis perspectiva* (the artifice of perspective) in which he discussed the diagonal lines

leading to the vanishing points used by Alberti to measure the distance of recession. These lines could be used to draw any object which was at an angle to the picture plane; this led him to use two vanishing points and situate them on the horizon line, thus making it possible to depict two lateral faces of the same building (fig. 31).

But they had to wait two hundred years before the ideas of Jean Pèlerin could be put into practice. In effect the first half of the 18th century the set designer **Ferdinando Galli**, from Bologna, introduced *the veduta ad angolo* in his decoration, forgetting the limitations of only one vanishing point. During this time the painter **Canaletto** confirmed the set designer Galli's discovery when he started *vedute* painting, produced with the aid of the camera obscura and without the limitations of vanishing points and perspective in general.

Fig. 28. Carlo Crivelli. *The Annunciation.* **National Gallery, London. In this painting Crivelli indicates his extraordinary knowledge of parallel perspective.**

Fig. 29. Leonardo de Vinci. *Study for the Adoration of the Kings.* **Uffizi Gallery, Florence. In the book** *Essays on Painting,* **published in 1651, Leonardo da Vinci discusses a series of points on perspective.**

Fig. 30. Albrecht Dürer. *Rest on the journey to Eygpt.*

Fig. 31. Jean Pèlerin published the book *De artificialis perspectiva,* **which established the horizon line and oblique perspective, by using two vanishing points, thus opening the way to new discoveries, until the full development, of perspective.**

28

29

31

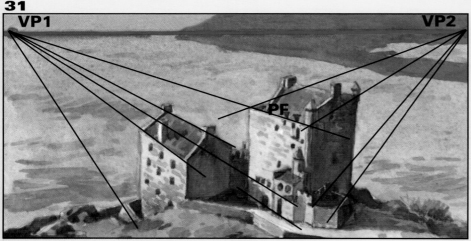

VP1 VP2

PF

30

The Cube: Parallel Perspective

Look, read and draw. On a piece of paper, with a pencil or pen, guided by the images in figure 32, draw a horizon line and then draw various cubes using parallel perspective, views from the front, above or below as I have done in this drawing of a street with the Monastery of St. Cugat in the background (fig. 33). Now let's construct the cube using parallel perspective. Start by drawing a square (fig. 32A). Draw the horizon line (HL) and, to the right of the square mark the vanishing point (VP) (fig. 32B). Draw four straight lines that join the four corners of the square to the vanishing point (fig. 32C). Now decide on the depth of the cube, tracing a parallel line to the edge of line b, drawing the face which will be the base of the cube, as if it were transparent, or made of glass (fig. 32D). From the verticals A and B of the last face, draw two vertical lines upwards to join the vanishing point lines C and D (fig. 32E). Finish the exercise by closing the gap between C and D on the top face of the cube (fig. 32F).

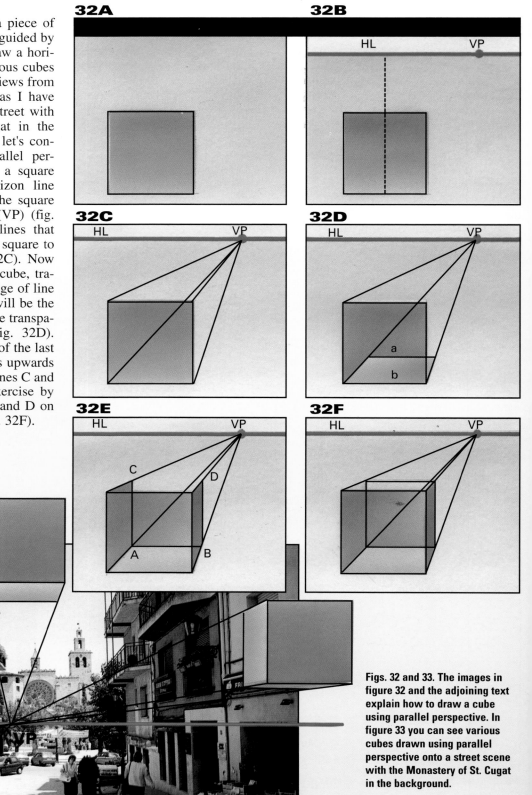

Figs. 32 and 33. The images in figure 32 and the adjoining text explain how to draw a cube using parallel perspective. In figure 33 you can see various cubes drawn using parallel perspective onto a street scene with the Monastery of St. Cugat in the background.

The Cube: Oblique Perspective

Now you come to the task of drawing various cubes using oblique perspective, as seen in the aerial view I have taken of the port in Barcelona, and that you can see in figure 35. Now look at the diagrams and read the following instructions. First draw the horizon line (HL), then mark vanishing point 2 (VP2) and draw in perspective the most visible side of the cube, taking into account that the edge lines A and B have to coincide at the vanishing point 2. Continue these edge lines, joining them to vanishing point 2 (fig. 34A). Now draw the other visible lateral side of the cube, continuing the lines C and D up to the horizon line thus obtaining vanishing point 1 (VP1) (fig. 34B). From corner E, trace a line up to vanishing point 2, and then from the corner F trace a line up to vanishing point 1. The cube will be complete (fig. 34C). However, to eliminate deformations, trace a line from the corner G to vanishing point 2, and then a line from corner H to vanishing point 1. Finally draw the vertical line I to J, with which you will have obtained a *glass cube*, which we will talk about in the following pages.

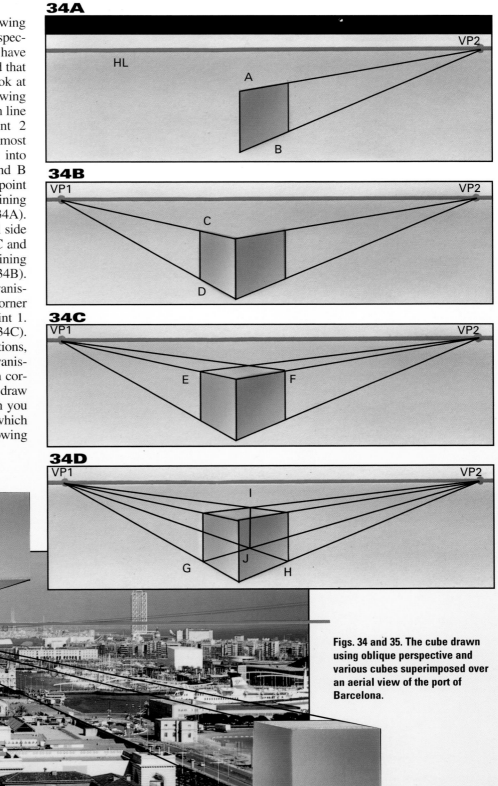

34A

34B

34C

34D

35

Figs. 34 and 35. The cube drawn using oblique perspective and various cubes superimposed over an aerial view of the port of Barcelona.

The Cube: Aerial Perspective

On one of my trips to New York I stayed at the Hilton Hotel and from the forty second floor, I took this photo (fig. 37) as an example of aerial perspective with three vanishing points. Let's examine this type of perspective step-by-step, bearing in mind that although three point perspective is used when drawing these buildings from above, you would also have to use three point perspective to draw skyscrapers if looking up from a very low viewpoint. Well, let's draw a cube with three vanishing points. Draw a square using oblique perspective (fig. 36A). Draw a vertical line that passes through the center of the square (fig. 36B). Trace a vertical line downwards from the nearest corner of the cube, remembering that this line will form the third vanishing point (fig. 36C). Draw the cube's lateral sides. The lines from edges A and B continue to form VP3, and the lines from edges C and D continue to form VP1 and VP2 respectively (fig. 36D). Extend the vertical lines to determine the third vanishing point, keeping in mind the dotted perpendicular from the horizon line (fig. 36E). Finally, draw the lines that complete the see-through glass cube (fig. 36F).

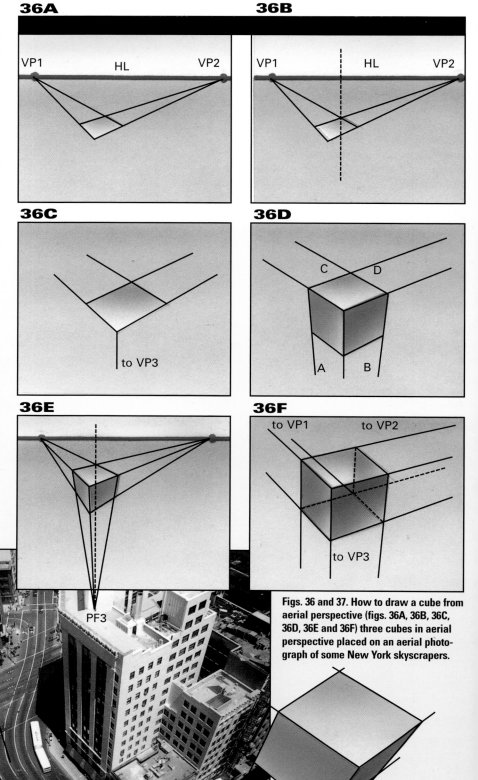

Figs. 36 and 37. How to draw a cube from aerial perspective (figs. 36A, 36B, 36C, 36D, 36E and 36F) three cubes in aerial perspective placed on an aerial photograph of some New York skyscrapers.

Errors in Drawing the Cube

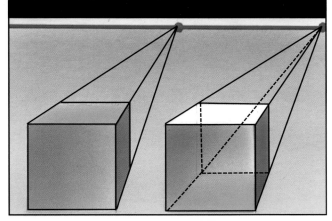

Appearances can be deceiving. It is possible when drawing a cube to make a serious mis-judgement of its depth. This is caused by drawing the top of the cube by eye and not taking the depth of the cube into account. If you look at figure 38 you will see how the error becomes obvious when we add the internal dotted lines describing the glass cube.

Now look at figure 39, which illustrates more common errors: these vertical lines are drawn so they converge, don't forget that they must be both vertical and parallel (A); the lateral sides are drawn outside of the vanishing point, i.e. without coinciding at the vanishing point (B); the depth of each of the cube's faces is not in proportion, resulting in squashed or stretched shapes (C). The most serious error is to deform the cube by drawing an angle of less than 90° at the base, it is physically impossible as all the faces of a cube or rectangular prism meet at 90° even when they are seen from a higher viewpoint. The text below figures 40A and 40B explains two rules to help avoid this error.

Figs. 38 and 39. Described in the text and seen in these two diagrams, the frequent errors that occur in the drawing of the cube using parallel perspective.

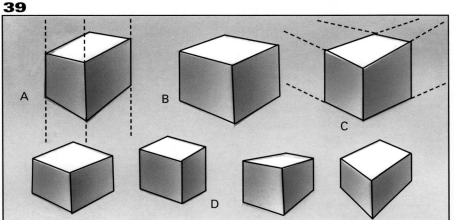

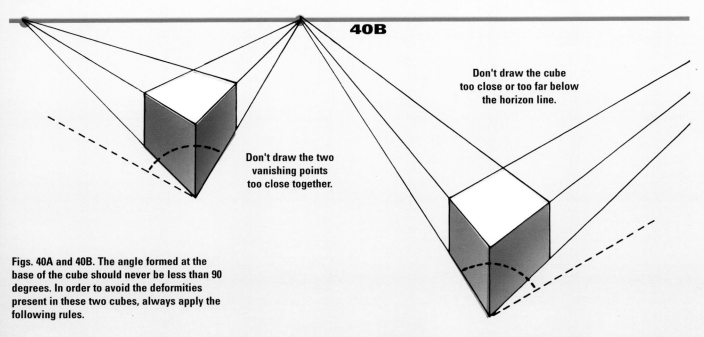

Don't draw the cube too close or too far below the horizon line.

Don't draw the two vanishing points too close together.

Figs. 40A and 40B. The angle formed at the base of the cube should never be less than 90 degrees. In order to avoid the deformities present in these two cubes, always apply the following rules.

Perspective of the Circle and the Cylinder

To draw a circle in perspective we first have to master the drawing of a flat circle. Good, well let's begin, in figure 41 you can see that we've started with a flat square (A) in which we trace the diagonal lines (B) and then a cross (C). Next we divide the diagonal in the bottom left hand corner into three parts (D) and draw a second square within the first (E), to which we mark eight points that we will use to guide us in the drawing of the circle (F). Now draw a square in perspective and repeat the previous instructions, which will easily enable you to draw a circle drawn in perspective (G, H and I). In figure 42 you can see some common errors that can occur when drawing the circle in perspective. In A, a circle drawn in oblique perspective, the error lies in the angle at the base of the square which has been drawn at less than 90 degrees. In B distortion occurs as a result of a rectangle being drawn instead of a square.

Fig. 41. To draw a circle in perspective, we must first start by trying to draw a flat circle , like we can see in A, B, C, D, E and F. Once this has been mastered, the same procedure can be applied to when drawing a circle in perspective (G, H and I).

41

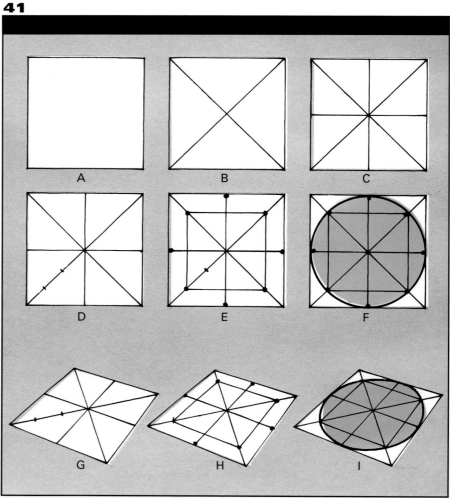

42

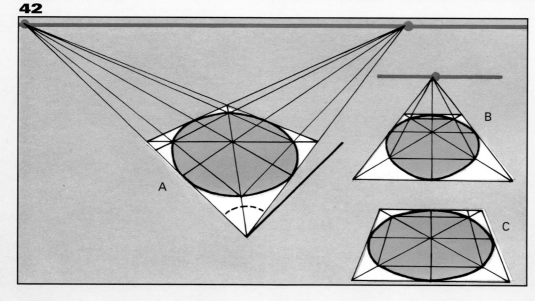

Fig. 42. Distortions in the drawing of a circle in perspective may occur if the nearest corner of the square is drawn with an angle of the less than 90 degrees (A) or because we have drawn a rectangle instead of a square (B). Great care must be taken to trace a perfect circle, something that has not been archieved in C.

To create a cylinder (fig. 43), means simply drawing an elongated cube, known as a rectangular prism, in the top and bottom faces of the cube draw the structure for a circle and then the circle itself (A and B), finish the cylinder by drawing two vertical lines joining the two circles together (C).

To correctly draw a cylinder in parallel perspective (fig. 44A), care needs to be taken in the positioning of the vanishing point in order to avoid distortions, like those in B, caused by positioning the vanishing point too far away from the center of the cylinder. In figure 45, we can see that the top circular face of the cylinder is more or less elipsed depending on the height of the horizon line (A): the thickness of the cylindrical tube varies when it is drawn in perspective appearing thicker at the sides and thinner in the center (B): the circle at the top of the vase should be drawn more elipsed than that of the base (C); and the base of the cylinder should be curved not angular (D).

43

44

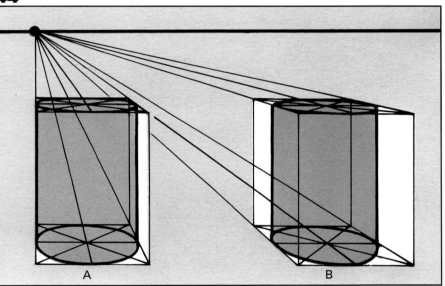

Fig. 43. To draw a cylinder, start with a rectangular prism (A), then add circles in perspective on the top and base (B). Two vertical lines join the circles at the top and base to complete the cylinder (C).

45

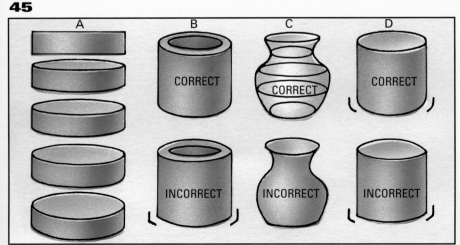

Fig. 44. In parallel perspective the vanishing point is situated not too far from the subject (A). Situate the vanishing point beyond a certain distance and the rectangular prism and the cylinder inside both become stretched (B).

Fig. 45. The circle forming the top of the cylinder is more or less elipsed dependant on its position in relation to the horizon line (A). The thickness of a cylindrical tube varies when it is drawn in perspective, appearing thinner at the sides and thicker in the center (B). The circle at the top of the vase should be drawn more elipsed than that at the base (C). The base of a cylinder should be curved not angular (D).

The Pyramid, the Cone, the Sphere

In figure 46 you can see that in the drawing of the pyramid and the cone, a cube or rectangular prism is used, a rectangular prism being an elongated cube, which we can see in the drawing of the cone (F). The drawing of both these forms is made very easy by using the framework of the cube. To build the pyramid, start by tracing in the diagonals on the top and bottom faces of the cube and then with a diagonal line join the two centers of the crosses (A and B). Like this you will be able to draw the pyramid shown in (C).

For the cone, once we have drawn the cube, or rectangular prism as in this case, trace the diagonals on the top and bottom faces (D) and draw the base (E) providing a framework for the cone (F).

46

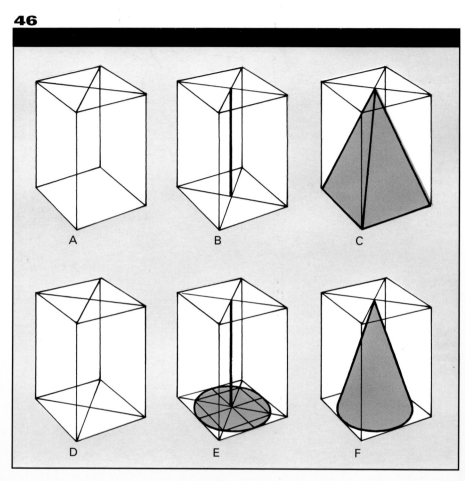

Fig. 46. Both the pyramid and the cone are drawn using the framework of a normal or elongated cube, to which crosses are drawn on both the top and bottom faces, as in the case of the pyramid (A, B, C), or a circle as in the case of the cone (D, E and F).

47

Fig. 47. Applied practice of the pyramid and the cone.

The drawing of a sphere, a ball, a balloon, a globe, etc., is a little bit more complicated, various circles have to be drawn within a cube in order to solve decoration problems such as those presented in the drawing of a rubber ball or hot air balloon. However, at this level, after studying the form of a circle in perspective, I don't think that you will find it too difficult to draw a sphere from various circles in perspective. You can see in figure 48 the formula used for drawing various circles within a cube, in horizontal, oblique and frontal positions, this will help you to draw a beach ball (F), football or tennis ball seen in figure 49 below.

48

A B C

D E F

Fig. 48. The drawing of a decorated sphere like a beach ball, football, tennis ball, hot air balloon, etc., involves drawing various circles, in different positions, within a cube, as we can see in A, B, C, D, E and F.

49

Fig. 49. Practicing spheres which, due to decoration, have been drawn with the aid of various circles drawn within a cube.

How to Find a Center Perspective

Here we have a formula that can be applied whenever finding a center perspective within a space, in a door, a window, etc. Diagrams A, B and C, in figure 50, illustrate this formula. In A we can see a flat surface in which, by marking diagonal lines that cross the space, we have marked its center. In the diagrams B and C we have applied the same formule by tracing the diagonal lines of the surface in parallel perspective, which has only one vanishing point.

In diagrams D and E we find the center perspective of the top façade and door through a system of crossing diagonals, taking into account that the façade has a different center perspective, slightly further forward, than that of the door which lies on a different plane, slightly further back in relation to the façade.

Finally, in the diagrams F, G and H you can see the formula in practice, always with the same traced cross, used to find the center perspective of a figure or subject in oblique perspective, two points.

Fig. 50. To find the center perspective of a square or rectangle drawn in perspective, you need only trace a cross in the space, which could be a window, door, mosaic, tile, or square with a central monument, etc., as we can see in these examples.

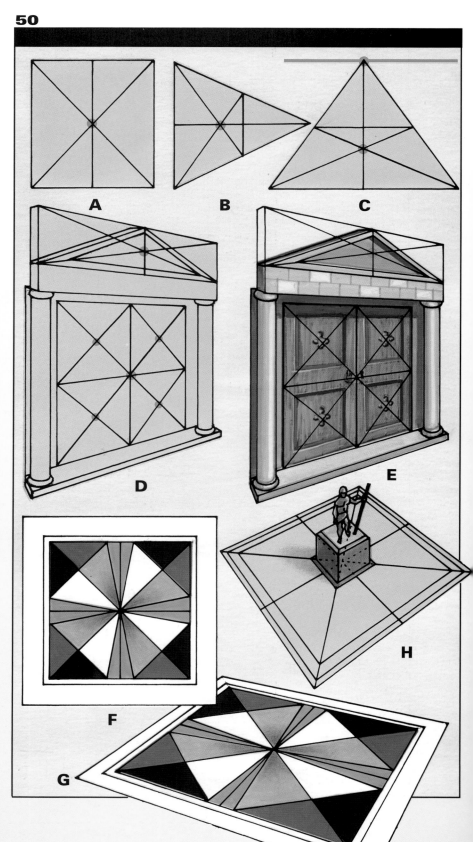

Help From the Use of Guidelines

51

We are going to imagine that you are drawing a house in oblique perspective, which has two vanishing points, like the one that we can see in figure 51. You find you have trouble with the two vanishing points that lie outside the boundaries of the paper on which you are drawing. How can you gain the correct inclination, in perspective, of all the details: chimney, roof, windows, doors, etc.?

The answer is easy: imagine that you are in front of the model and you have drawn the dimensions and proportions, but the inclination and perspective of the details need to be adjusted and corrected (the professional expert will be able to calculate perfectly the inclination and perspective of the building by eye). However let us go on to form the guidelines which will automatically solve the problem. See in the following diagrams (figs. 52 and 53) the instructions to follow when forming these guidelines.

Fig. 51. Here we have a house in Great Britain, that has been drawn in oblique perspective, that of two vanishing points. You may come across many different problems, one of them being: the vanishing points lie outside of the paper's boundaries. What can you do? Well, the solution is found in the following figures 52 and 53: with the help of the guide lines we are able to draw all the details in perfect perspective (walls, roofs, chimneys, windows and doors).

Fig. 52. Start by tracing the vertical line A on the closest corner of the building. Next, divide this vertical line into various equal parts, in this case six. Draw a continuation to the diagonals, B at the top of the building and C at the floor of the building, corresponding with the building's boundaries.

Fig. 53. Draw vertical lines outside of the picture on both the left and right side, divide these lines into six equal parts, like you have done for the center vertical line A. To finish, you only have to trace a series of diagonal lines from the points on the center vertical line to those at either side, thus building your framework of guide lines.

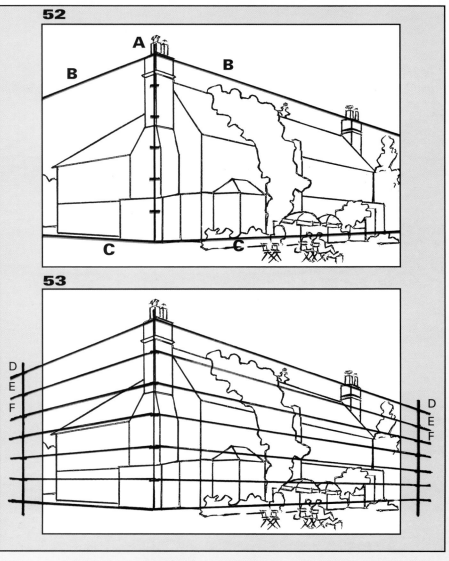

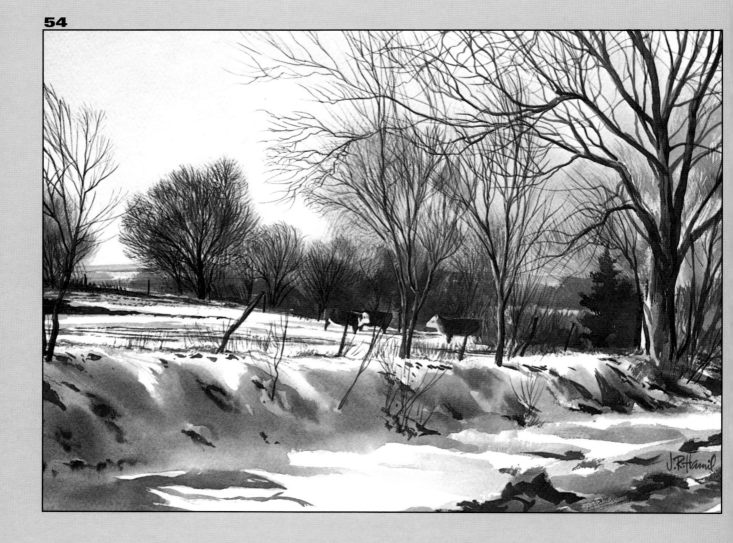

Fig. 54. James R. Hamil. *Cows in Winter*. Private collection, Kansas. Courtesy of Southwind Press. I met the North American watercolorpainter at a book fair in Frankfurt. I was going around the fair with my books when I came across a stand with watercolorpaintings and books. Amidst the paintings I saw this snowy landscape. James knew my books. I told him that I wanted to publish his painting and he gave me his book *Return to Kansas*, saying happily "And here you have it!". So I thought that it was a good illustration to use when talking about where to paint.

WHAT
AND WHERE
TO PAINT?

First we have to decide, and find, what we are going to paint. A country landscape, an urban landscape, an interior, a still life...? Then, where we are going to paint: outdoors, in the country, in the city, in a town, at home...? One could think like **Renoir**, that anything can be used as a subject, or, like **Cézanne**, that any place is a good place, as he wrote in a letter to his son Lucien from Aix: *"Here on the banks of the river, the choice is endless"*. This chapter attempts to solve the problem of what and where to paint, lending a hand to many professionals, who answer and solve this dilemma looking and studying the works of the Great Masters (let us remember the historian **Wölfflin** when he said *"A painting owes more to other paintings than it does to the observation of nature"*), seeing in the works of other painters where they painted, learning, by looking at other paintings, the best settings, and later, in our own time, finding a valuable aid in photography.

A Lesson from the Great Masters

55

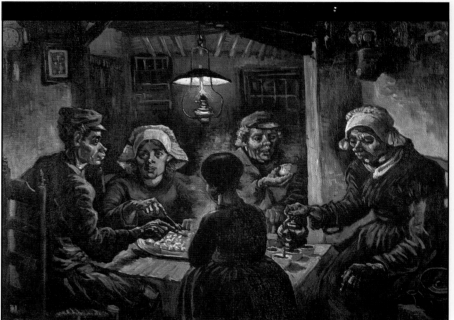

Van Gogh, in his early years as a painter, when he was in Nuenen (Holland), worked his paintings with a range of dull colors. We can see an example of this oppresive style, with its range of unattractive colors, in the painting *The potato eaters* (fig. 55). It's a painting famous for its palette of colors, that dramatize and enhance the social aspect of the painting. During this time, 1878-1880, Van Gogh employed this dark palette of colors for all of his paintings (fig. 56).

But eight months later he went to Amsterdam, and in the Rijks Museum he was introduced to the works of Rubens and Rembrandt, and four years later, Van Gogh went to Paris where he met the greatest masters of that time, **Delacroix, Corot, Courbet,** and the artists responsible for an advanced, brighter art: the Impressionists **Monet, Cézanne, Degas, Pissarro** (figs. 57 and 58) and watching them, painting with them and being with them, Van Gogh learnt the great lesson of light and bright colors. From then onwards Van Gogh painted red dresses and skies of yellow and green (figs. 59, 60 and 61, opposite page).

You too can be like Van Gogh, but without having to go to Paris, to the Musée d'Orsay; by simply looking and learning from **Corot, Courbett, Monet** and all the other Impressionists from art books and pictures, looking and studying the palettes of colors, observing their contrasts, formats and viewpoints, etc., in the reproductions of their paintings (fig. 62, opposite page).

56

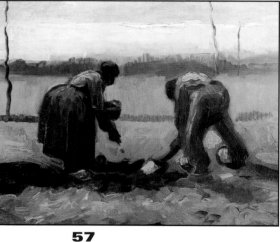

Figs. 55 and 56. Van Gogh. *The potato eaters*. Nuenen, April 1885. Rijksmuseum, Amsterdam. *Farmers planting potatoes*. Nuenen, April 1885. The paintings painted in Nuenen were Van Gogh's social manifesto in the tradition of Millet or Breton. Van Gogh considered, and even said to his brother Théo, that "the painting of the farmers eating potatoes is the best of all of my works".

58

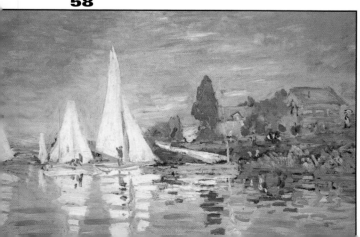

57

Fig. 57. Peter Paul Rubens. *Portrait of Elena Fourment*. Rijksmuseum, Amsterdam. In April 1885 Van Gogh painted *The potato eaters* and eight months later, in November, he went to live in Amsterdam. There he visited the Rijksmuseum where he saw paintings by Rembrandt and Rubens, which influenced him to incorporate brighter and more intense colors into his palette.

59 **60**

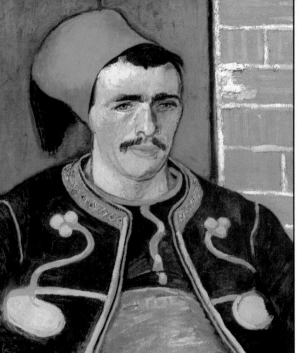

61

62

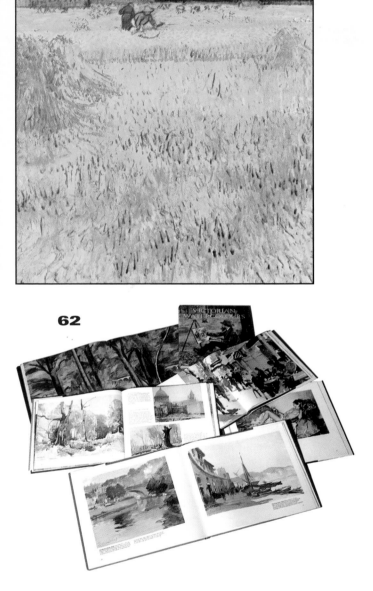

Fig. 58 (opposite page). Claude Monet. *Regattas in Argenteuil*. Musée d'Orsay, Paris. In May of 1886, Van Gogh travelled to Paris and his brother, Théo, an art dealer, introduced him to Monet, Renoir, Pissarro, Sisley, etc. Once Van Gogh had became familiar with the paintings of the Impressionists, he altered his palette dramatically.

Figs. 59, 60 and 61. Van Gogh. *The zuavo*. Rijksmuseum, Amsterdam. *Wheat field with a view of Arles*. Rodin Museum, Paris, and *Gypsy camp with caravans*. Musée d'Orsay, Paris. Lessons from the Great Masters such as Rembrandt, Rubens, Monet and the Impressionists influenced Van Gogh to such an extent that by 1888, when in Arles, he was painting with red, yellow, blue cobalt and emerald green.

Fig. 62. It's easy to visit museums and art exhibitions, or to look in art books that have good reproductions of paintings. There are many and they represent, without doubt, an excellent source of information and ideas, a great lesson in subject, composition and interpretation.

Painting Where They Painted or Where They Paint

If you see a place where an artist is painting, write it down! Painting where others have painted is nearly always a valid exercise (figs. 63A and 63B). Through visiting museums and art exhibitions, and consulting art books you will find lots of places that the professionals and Great Masters painted, that you too can paint: the parks and gardens that Van Gogh painted (fig. 64); reflections and the water of a sea or river, a subject used in many a Monet painting (fig. 65, opp. page), or the entrance to a village, a subject chosen many times by Pissarro (fig. 66, opposite page).

Paint where the artists paint. Why not take on some drawing and painting classes, this is another solution to your question of what and where to paint (fig. 67, opposite page). You can paint where the artist paints by attending their classes and you will also see what they are painting, how they sketch, how they start off each picture, how they mix colors and how they hold their brush. All this gives you the opportunity to take advice and guidance from a teacher, who helps you to alter and to improve your work, in short, to learn. In every city, big or small, there are centers, schools or academies that hold classes in drawing or painting. Sign yourself up for daily classes or for classes every other day for six months. This gives you sufficient time to improve your technique and to learn what and where to paint.

What would you say to me about painting a still life inspired by those of Cézanne? (fig. 68, opposite page). I studied various still lifes by this artist before painting one of my own of this genre. Using this composition, that I photographed in my studio as a model (fig. 69, opposite page), I conceived and painted the painting in figure 70 (opposite page): a still life inspired by the still lifes of Cézanne.

63
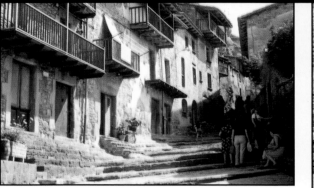

63A

63B

Figs. 63, 63A and 63B. This is a typical and picturesque street in a town called Rupit, some 60 kilometers from Barcelona (fig. 63). It's a place where some time ago I painted a watercolor painting (63B) and where it's always easy to find someone painting the same scene in exactly the same place (63B).

Fig. 64. Van Gogh. *A couple in The park at Arles: The garden of the poet* III. Private collection. Van Gogh painted at least six more paintings of the gardens of the park of Arles, almost always painting couples or peasants.

64
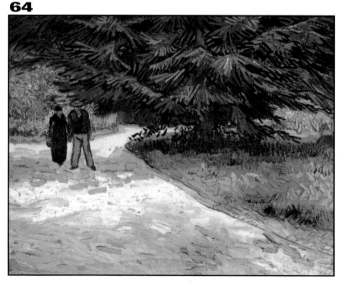

65

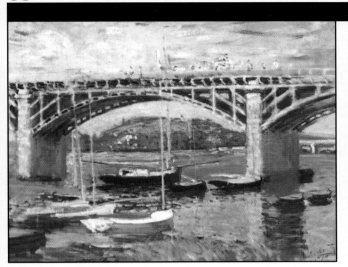

66

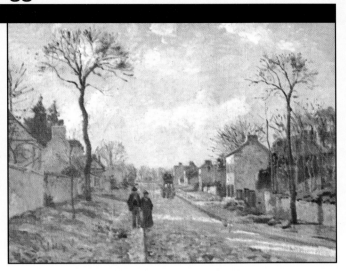

Fig. 65. Claude Monet. *The bridge of Argenteuil*. Musée d'Orsay, Paris. The majority of Monet's works were painted by the river Seine or the port at Le Havre. He even has a boat from which he would paint the water and reflections, and, as is well known, at his house in Giverny he constructed a lake which inspired him to paint numerous pictures with reflections of clouds, flowers, water-lilies and aquatic plants.

Fig. 68 Paul Cézanne. *Curtain, vase and plates with fruit*. Hermitage Museum. St. Petersburg. In a number of his still lifes, Cézanne used a white cloth to partially cover the table, plates of fruit and a basket, a jug or, as in this case, a vase. The curtain is a detail exclusive to this painting.

Fig. 69. This is a still life that I composed and photographed in my studio, with the previous painting by Cézanne in mind.

Fig. 70. José M. Parramón. *Still life with blue vase*. Collection of the artist. Apart from the curtain, the details are the same if not very similar to that of the painting by Cézanne: a white cloth partially covering the table, a blue ceramic vase with a red rose, a plate of fruit and pieces of fruit laid about the table, a neutral background, a chair, a glimpse of a door on the right and a painting on the left.

Fig. 66. Camille Pissarro. *The road. Louvenciennes*. The Louvre, Paris. Corot, Pissarro and many other Impressionists used paths and roads into villages as a motif. I myself have used this same theme which makes for an interesting subject to paint.

Fig. 67. Paint where they paint. This is a photo of the School of Watercolor of the Catalonian Watercolorist Association, a place where every day of the week dozens of keen students gather to paint under the supervision of professional artists.

67

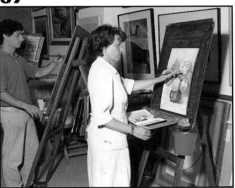

68

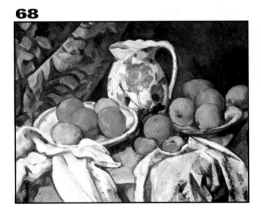

69

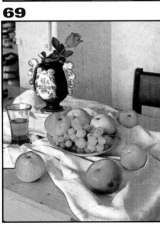

70

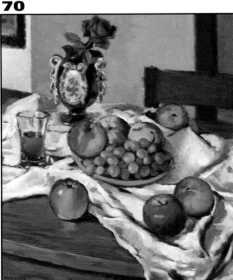

Selecting the Subject using the Setting

71A **71B**

"*Here on the banks of the river*, wrote Cézanne to his son Lucien, *the choices are endless, the same scene viewed from a different angle offers a subject and style more alive with possibilities, so varied, that I think that I could work for months without changing place, leaning sometimes just a little to the left or to the right*". It sometimes happens, in specific places, that there is a choice of subject or that the scene isn't well defined. You may then need the help of a viewfinder, to view the scene through two black cardboard angles that together form a frame (figs. 71A and 72B), with which you can frame, view and select the scene (figs. 72A, 72B and 72C). This method of using two black cardboard angles also allows you to find scenes that correspond to your predetermined scheme, affirming the artistic composition of the landscape, the seascape, still life, etc. (figs. 73, 74 and 75, opp. page), and going on to discover the idea that **viewfinding is composing**, an aspect that we will come to later on.

72A

Figs. 71A, 71B, 72A, 72B, 72C and 72D. Two black cardboard angles, approx. 24 cm x 20 cm each (fig. 71A), allow you to make a frame that can be held up (72B) to view and frame an image, selecting sections of the land or seascape giving a better indication of what to paint (figs. 72A and 72B). Look at fig. 72D (opposite page) a diagram of a composition, corresponding with that selected (fig. 72C) from the landscape.

72B

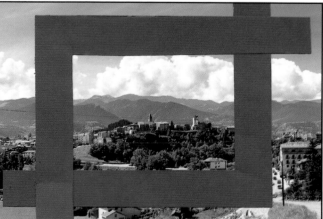

73A

73

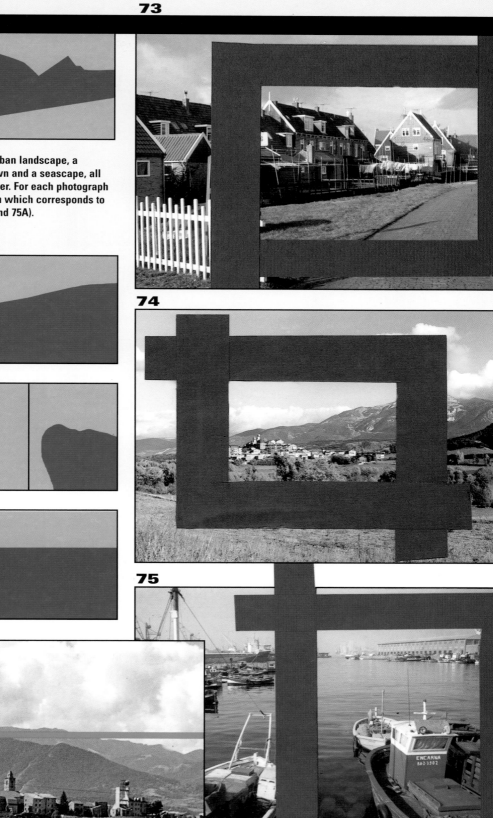

Figs. 73, 74 and 75. Examples of an urban landscape, a landscape with a mountain and a town and a seascape, all with scenes selected in the viewfinder. For each photograph you can see a compositional diagram which corresponds to the selected scenes (figs. 73A, 74A and 75A).

74A

75A

72D

72C

74

75

Selecting the Subject with the Help of Photographs

If you have a camera, photography can be your first aid in the selection of a scene. In the first place, photography can help you find a better viewpoint and composition. Not long ago, next to a river, close by to a country house I found a landscape that was perfect to paint. The scene deserved a painting, but where was the best viewpoint? With the country house in the foreground, background or in the distance? With these doubts, I took some photographs (figs. 76, 77 and 78) and then back in the studio I decided which would be the best viewpoint. This selected photo (fig. 78) has helped me to develop a landscape step by step, as you can see on the next page (figs. 79, 80, 81 and 82), because painting from photos is the second factor in using a camera as an aid. *"I don't know Mr Rothstein,* wrote the Impressionist Claude Monet to his art dealer, Durand-Ruel, *but I know Mr Harrison, to whom Sargent has given the task of taking a photograph of the Houses of Parliament for me, photos which I've never seen and could never use. It matters little whether my Cathedrals, my London scenes my other canvases are painted from life or not, nobody sees them and they are of no importance. I know many painters that paint from Nature and never achieve anything but ugliness. The final outcome of a painting is what matters and not the means you have used to achieve that result".*

Well, he didn't paint all of his paintings using photography. When Monet was just starting out, as a simple caricaturist, he met the painter **Boudin**. *"Why don't you try painting?"* Boudin said to him. So Monet went out painting with Boudin. *"Everything that is painted directly from life always has a strength, an energy, a vigor that you find in no other media or technique",* Boudin said to Monet. These words for Monet were like a revelation. When he was 68 years old he painted in Venice: *"Here I spend delicious moments painting this unique light, forgetting that in reality I am an old man".* In Venice, Monet painted from real life as usual (fig. 84).

76

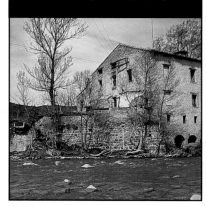

77

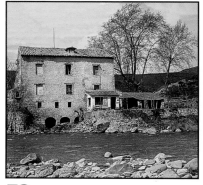

78

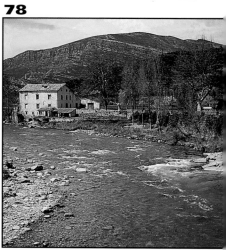

83

Fig. 83. Claude Monet. *Rouen Cathedral.* Musée d'Orsay, Paris. Monet worked on his Cathedral paintings for months, moving from one canvas to another depending on the direction of the light. In total he painted fifty paintings. *"I get up before six and work until seven thirty in the evening, all the time standing, nine canvases, it's killing me".*

84

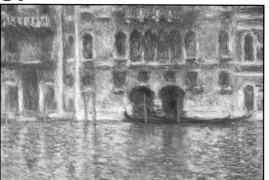

Figs. 76, 77, and 78. I was looking for a scene to paint, when I saw this country house next to a river. Unsure which was the best viewpoint and composition, I took these three photographs. Then in the studio I chose the image in figure 78.

79

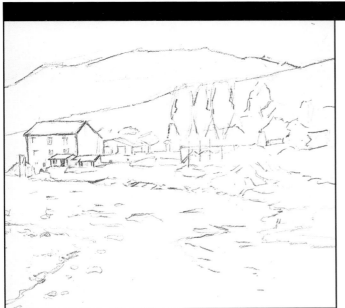

80

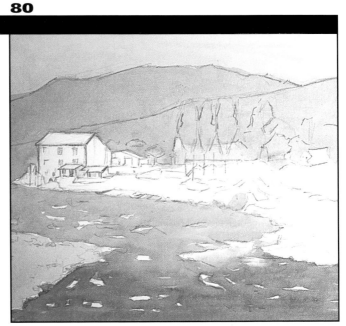

81

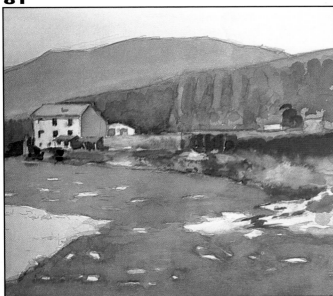

82

Fig. 84 (opposite page). Claude Monet. *Mula Palace, Venice*. National Gallery of Art, Washington D.C. Chester Dale Collection. When Monet was 68 he still travelled to Venice, painting paintings like this one, admiring the light and colors and lamenting the fact that he never visited Venice when he was a young man.

Figs. 79, 80, 81 and 82. A step-by-step watercolor of the scene selected (fig. 78, opposite page). Fontenay de Canson paper. The picture's composition is set slightly to the left, shifting the country house a little to the right (fig. 79). First stage: the sky, and the mountain in the background are painted with a less intense color than that of the photograph, a way of producing atmosphere and depth, and the river with foam on the waves and the stones or shore on the right painted a white (fig. 80). Third stage: general intonation; the mountain in the middle-ground with trees, the house on the right hand side and the shadow and the area next to the house on its right side (fig. 81). Final stage: general finish that includes the angle of the sand and stones in the foreground on the left hand side, the stones in the river, etc. (fig. 82).

The Preliminary Sketch

85

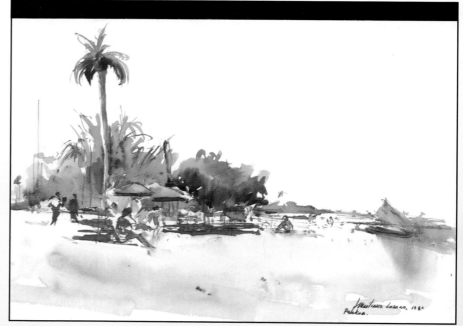

Why do we draw a sketch or outline before painting a picture? I have answered this question in many of my books, when I talk about drawing or painting with the freshness, the looseness and the philosophy of the preliminary sketch: A creative philosophy, born from the unknown miraculous adventure, of spontaneity and of the absolute freedom from the worry of the act of actually drawing or painting the preliminary sketch, **not the final picture**. Because the sketch is no more than a rough, an approximation. It is because of this, this idea of an experiment or approximation, that one lets oneself go, to launch, to dare to try the outline with a softer pencil and the brushstrokes with a fatter brush.

The watercolor by **Martínez Lozano** (fig. 85) is a good example of a watercolor where the artist has started by using a sketch and has ended with a finished study.

Gaspar Romero painted this study of a grapefruit and a coffee pot as a simple exercise in color and reflection. *"I was in the kitchen at home one day*, explains Gaspar Romero, *when my attention was drawn to the reflection of the grapefruit in the coffee pot. I took the grapefruit and coffee pot to my studio and painted this study* (fig. 86)."

I myself, one day, had the opportunity to attend rehearsals of *The Messiah* by Handel, with Ros Marbá as the conductor. I drew a series of sketches of him using pen and Chinese ink with a few touches of watercolor (fig. 87, opposite page). Look at the study of a vase of flowers (fig. 88, opposite page), the preliminary sketch (fig. 89, opposite page) of a landscape of a street in Rupit (the final watercolor is illustrated on page 32) and the sketched portrait of a friend of mine drawn using a 6B lead pencil (fig. 90, opposite page).

86

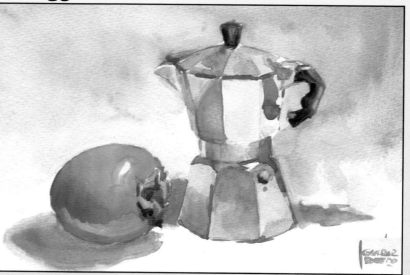

Fig. 85. Martínez Lozano. *Beaches of Pattaya.* Artist's collection. Martínez Lozano is a master in watercolor painting, controlling form, color and, in a special way, the synthesis. Here, where the artist started the watercolor with the two trees and vegetation in the background, demonstrating his capacity to summarize and synthesize forms and colors.

Fig. 86. Gaspar Romero. *Grapefruit and coffee pot with reflections.* Artist's collection. In relation to the explanation, Gaspar Romero started to paint this scene without any worry of its importance. Thus producing a study that, for its quality in drawing, technique and contrast, deserves the title of a finished picture.

87 **88**

Fig. 87. José M. Parramón. *The conductor Ros Marbá directing Handel's The Messiah.* Artist's collection. Sketches of figures like this one, with such movement, don't happen the first time around. Various sketches previous to this one exist so that later the closest, most accurate likeness can be chosen.

Fig. 88. José M. Parramón. *Sketch of a vase with flowers.* Artist's collection. A small study, a training, for the quick and spontaneous response to painting in watercolor. Something that you should do with the same or a similar subject.

89 **90**

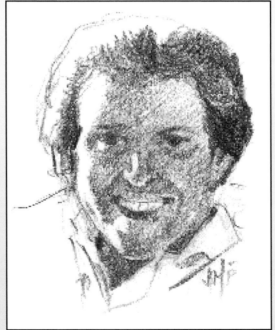

Fig. 89. José M. Parramón. *First sketch of a street in Rupit.* Artist's collection (the finished watercolor is on page 32). It is a "postcard size", study which follows the advice given to a student by the painter Maurice Denis: *"And don't let yourself abandon this first fresh idea for anything in the world".*

Fig. 90. José M. Parramón. *A sketched portrait of a friend.* Artist's collection. In another volume of *a Practical Course in Watercolors, various Diverse subjects step-by-step,* we studied the theory of portraiture, a formula that is used in the drawing of heads like this one and that I hope you learnt and practice to draw the portraits of your family and friends.

The Preliminary Sketch

91

Fig. 91. This is the subject: a landscape near to the French border, with some country houses next to a cluster of trees of strongly contrasting colors, where a large tree stands out –ochre, yellow and crimson in color–, on the right hand side of the middle ground. And in the foreground, a large green field. Studying the subject, the most complicated and difficult area is that of a cluster of trees on the left, due to their forms that, although they are real, appear abstract.

92

Fig. 92. First I draw the subject on an English Whatman paper that has a thick grain to it, first with a B pencil and then, reinforcing the preliminary lines with a softer 6B pencil, so that the drawing stands out cleanly enough to photograph for this first step. Although it is only a sketch, draw quite meticulously, including details that can be painted later with more confidence.

93

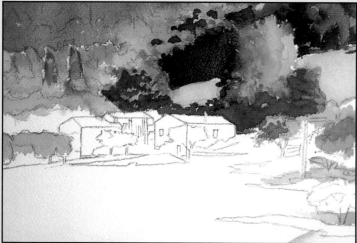

Fig. 93. First, I apply a general wash of light, but irregular tones, a sludgy green mixed from permanent green and carmine. I noticed from the beginning the different hues within the cluster of trees, these tend to be an autumnal carmine color, which in a lighter tone can also be used for the large tree to the right of the group of houses.

94

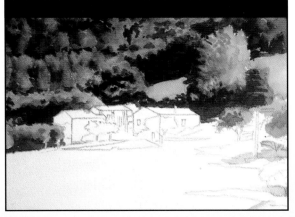

Fig. 94. I continue with the background shaping the forms with dark tones, black, a mixture of emerald green, carmine and, in the darkest areas, Payne's gray and Prussian blue. With so much dark color the pencil drawing has practically disappeared and I keep referring to the landscape so I can mold these abstract forms into more recognizable shapes.

95

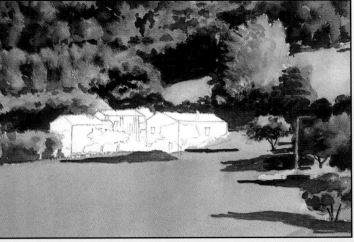

Fig. 95. I then paint the grass of the field in the foreground: permanent green, ochre and dark yellow. I then begin to bring out the detail in the group of trees and the shadows of the grass on the right of the foreground, leaving the final touches till later.

96

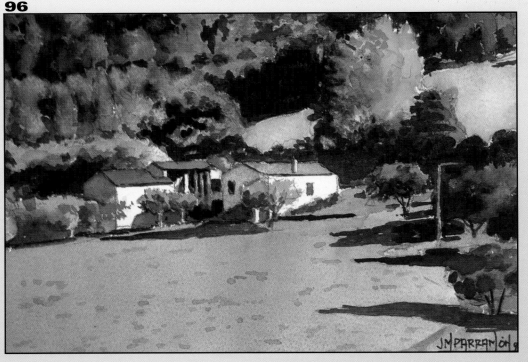

Fig. 96. Next I paint the farm houses and the trees next to them: carmine and ochre with a smidgen of Payne's gray on the roofs; Prussian blue, carmine and a little ochre for the shadows on the walls; carmine and black in the darkest areas; and the trees, ochre in the lighter areas and green, carmine and Payne's gray in the shady areas. I finish the group of trees and the land in the foreground and start on the finishing touches, carefully re-working the trees in the background, concentrating especially on the prominent red-yellow tree. Finally, I add the little smudges to the field in the foreground, painted a hint darker with a touch of Payne's gray and quite a bit of water, to recreate the slightly uneven ground and tussocks of grass. Then, I add my signature.

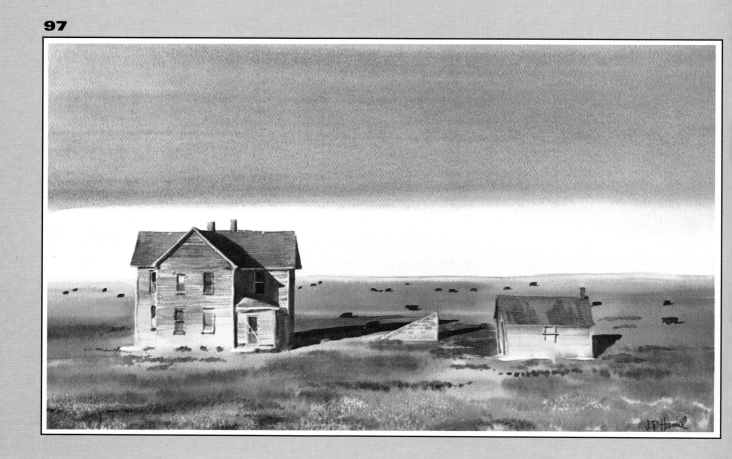

Fig. 97. James R. Hamil. *Ranch near Hoisington (Kansas)*. Courtesy of the South-wind Press. It is no coincidence that James R. Hamil has created the white strip on the horizon that divides the land from the sky, the irregular division of space within the picture plane is an example of the law of the Golden Section develo-ped by Euclid the Greek philosopher. As I said, this is not pure chance, the artist is an expert and has divided the space into unequal parts, intuitively establishing a more effective aesthetic both compositionally and artistically.

The Art of Composition and Interpretation

Some artists have tried to determine rules for the art of composition and interpretation. **Henri Matisse**, for example, wrote this:

"The art of composition is the art of organizing in a decorative form the different elements that the painter has to express his sentiments".

A sentence that doesn't solve the problem in a concrete way, because "which are these elements and what should I do to organize them?", asks the enthusiast. The French painter **André Thorez** summarized in these three words the art of interpretation:

Exaggerate, Supress, Omit.

"There are no rules –wrote the celebrated **John Ruskin**–. *If it was possible to compose and interpret form rules, **Titian** and **Veronese** would be normal and vulgar men"*. Ruskin had a point, but we are now going to look at some factors which can help in the composition and interpretation of a picture. Let us consider them in the following pages.

Unity within Variety

Fig. 98. The Greek philosopher Plato established a formula to help resolve the issue of artistic composition.

Besides Henri Matisse, there have been many artists and teachers who have tried to define the art of composition. For example, Cézanne said: *"Painting is the art of combining effects, in other words, the art of establishing relationships between colors, contors and planes"*.

They are ideas, but that said, ideas alone cannot define exactly how to compose and paint a picture in an artistic manner.

However, thousands of years ago, the Greek philosopher **Plato** (fig. 98) addressed this problem by establishing the following rule:

Composition is about finding and representing Unity within Variety.

The writer and critic, ex-curator and honorary president of The Louvre, René Huyghe, commented in his book *Dialogue with Art*, with regard to Plato's rule that to represent Unity to excess would result in a monotonous and poorly conceived work, he comments that:

"This Unity must be enriched by developing the Diversity".

So, diversity must exist in the variety of colors and forms, the position and the setting of the elements in a picture. As Huyghe suggested, it is necessary to combine both of these factors in such a way that the picture consists of:

**Unity within variety
Variety within unity**

This balanced equilibrium between unity and variety basically depends on the following factors:

Vary the format to achieve the best means of Unity:

a) **Better organization.**
b) **The adaptation of the subject of the scene to a set geometric format.**

Variety within unity may be achieved through:

a) **The dramatization of contrasts of tone and color.**
b) **The enhancement of texture.**

The painting *Landscape. Study of Nature*, by Paul Cézanne, below (fig. 99 and 99A) is a perfect example of Unity within Variety: due to its diagonal format, which forms the Unity; due to its color, that affirms the Diversity, and because the horizon line is situated in accordance with the law of the golden section (fig. 99A).

Fig. 99. Paul Cézanne. *Landscape. Study of Nature*. Private collection, Switzerland. This Cézanne painting is a good example of the rule of unity within variety and variety within unity, which you can compare with the diagram in fig. 99A.

Fig. 99A. First try to obtain, as Cézanne did, the factor of Unity through a very concrete diagonal compositional format (red line), at the same time achieving an extraordinary effect of variety from the diversity of the tones and colors within the space of the diagonal format. Cézanne also accentuates the quality of composition by applying the law of the golden section, indicated by a red line on the horizon.

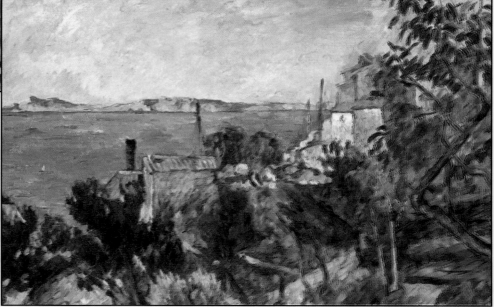

Euclid's Golden Section

You now have the easel with the board and paper ready to paint a watercolor... but wait a minute! Before starting to draw and paint, ask yourself the following questions: Is there a central point of interest in this chosen scene, a group of houses, and end to the horizon, with a town in the background, for example, that could be considered the most important subject of the painting? Is this the best setting, or composition? Does it respond to a geometrical format? Also, have you thought about raising or lowering the position of the selected setting so that the cluster of houses or the horizon coincide with the law of the golden section suggested by **Euclid**?

Who is Euclid and what is the golden section? Well I'll explain it to you right now; but first let me tell you that the selection of the setting, looking or framing it higher or lower, more to the right or to the left, is as Cézanne told his son Lucien, a basic factor in the selection and composition of a painting. Because selecting the setting is the same as selecting the composition. I'll repeat it again in bold type:

**Selecting the setting is
selecting the composition.**

Now let us go on to Euclid and the law of the golden section. In 300 BC, in Alexandria, lived the famous mathematician Euclid, author of the book *Elements,* in which volume IV studies the aesthetics of proportion and established the ideal division of a given line or space.

More than fifteen centuries later, during the Renaissance period, **Luca Pacioli**, the most famous mathematician of the 15th century, discovered the works of Euclid and wrote the book *De divina proportione*, illustrated by **Leonardo da Vinci**, in which he explained the formula of Euclid under the titles *the golden rule, golden point or law of the golden section.*

If you look at the text and images below you will see how Van Gogh has applied the law of the Golden Section in his painting *Wheat fields under cloudy skies* (figs. 100, 101A, 101B, 101C, and 102).

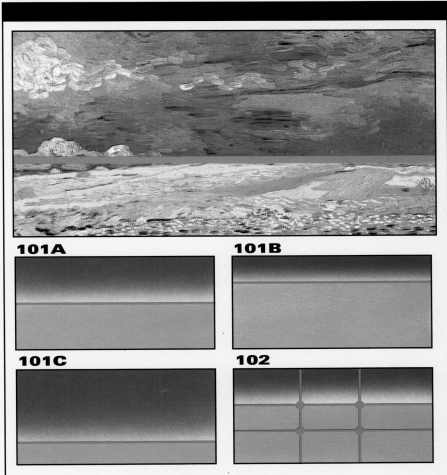

The law of the golden section

Figs. 100, 101 and 102. In the painting *Wheat field under cloudy skies*, Vincent van Gogh, Rijksmuseum, Vincent van Gogh Foundation, Amsterdam. Van Gogh could have placed the horizon line of the fields in the middle of the painting (fig. 101A), in the upper part of the painting (fig. 101B), or in the lowest part of the painting (fig. 101C). But no; he placed the horizon in the ideal place (fig. 100, top image) because he knew the law of the golden section:

**In order that a given space, divided into unequal parts,
appears pleasing and aesthetic, there should be the same relation
between the smallest and the largest part,
as that between the largest part and the whole.**

To find this ideal division, is easy enough, you multiply the height and the width of the painting by a factor of 0.618. If you multiply by the width and the height, you will find the golden point or the principle, ideal center to the painting. In addition take note that this golden point or ideal focus for the composition occurs at any of the four points indicated in figure 102.

Unity from the Painting's Format

Many Renaissance paintings, in particular those with religious themes, were conceived using a triangular format. **Rafael** like Leonardo da Vinci saw in this geometric formula a way of attaining Unity recommended by Luca Pacioli in his book *De divina proportione* (figs. 103 and 104). Later came the Baroque period, and Rembrandt, who, from what we can see, found the geometrical format a solution that offered great Unity but little Diversity, so he invented the diagonal format or composition. A compositional format also used by **Velázquez** and many other artists of the 17th century (figs. 105 and 106). In the time that followed, the majority of artists understood the compositional format to be the basic structure in a painting that generated Unity and prompted the art of composition. They looked for, consequently, many other different compositional formats, examples of which you can see on page 47.

Also, in our time, a psychophysicist called **Fischer** developed a questionnaire in which he asked a large group of people what compositional formats they preferred between a variety of *natural forms* (the silhouette of a head in profile, a hand, a leaf of a tree, etc.), a series of *abstract forms* or a series of *geometric forms* (a square, a circle, an oval, compositional formats in the form of an L, T, Z, S, etc.).

The majority of the people asked preferred the series of geometric forms (figs. 107, 108 and 109, on the next page).

103

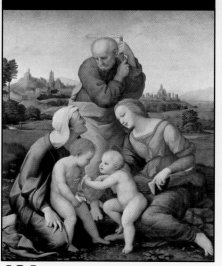

104

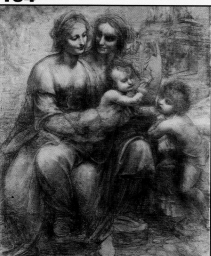

105

105A

Figs. 103 and 103A to 106 and 106A. Rafael. *The Sacred Family with Saint Anna and Saint John.* Pinaacoteca Antigua, Munich (fig. 103). Leonardo da Vinci. *The Virgin and child with Saint Anna and Saint John the Baptist,* on board. National Gallery, London (fig.104). Velázquez. *The Temptation of Saint Thomas of Aquinus.* Diocesiano Museum, Orihuela (Alicante) (fig.105). Rembrandt. Bathsheba bathing. Legado Louis La Caze. The Louvre, Paris (fig. 106). The geometric forms like these compositional diagrams were used in the Renaissance and the Baroque periods.

103A

104A

106A

106

Figs. 107 and 107A. Edward Wesson. *Surrey landscape*. Private collection. Courtesy of editorial David and Charles. Here you have a well designed and magnificent watercolor due to its fluidity, its synthesis of form and color and its delicate juxtaposition in the foreground, with its palette of warm colors, Sienna, ochres, dark yellow, etc., and the background with its palette of cool colors, grays, blues, etc.

107

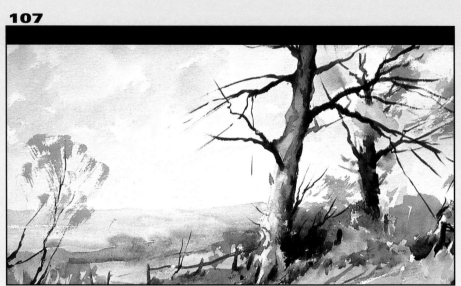

107A

108

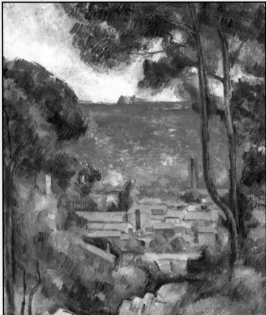

109

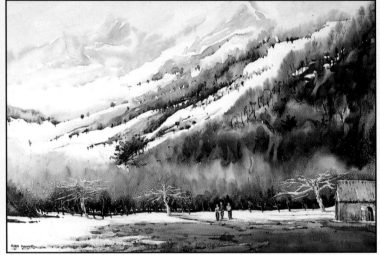

108A

109A

Figs. 108 and 108A. Paul Cézanne. *View through the trees in L'Estaque*. Private collection. Cézanne emphasizes depth by his lack of detail in the foreground, and with the yellows and reds of the houses he brings forward the middle ground while distancing the blue sea in the background. Furthermore, Cézanne frames the scene using a compositional format that strengthens the Unity of the painting; if you add to this factor to the Variety of forms and colors within the whole, we find ourselves standing before a magnificent example of artistic composition.

Figs. 109 and 109A. Siro Manuel. *The valley of Pineta, Catalan Pyrenees*. Private collection. My good friend Siro Manuel paints watercolors with an enviable chromatic technique and vision, as can be seen in this row of ochre-sienna trees in the foreground, painted wet on wet, or as in the three closest trees, presumably painted out with latex, or in the lighter and darker washes of the tones which lead towards the background and the mountains going into the distance. To assure the Unity of the subject, Siro Manuel frames the scene using a diagonal composition (109A) that emphasizes the overall good composition of the painting.

Variety in Terms of Contrast and Texture

110

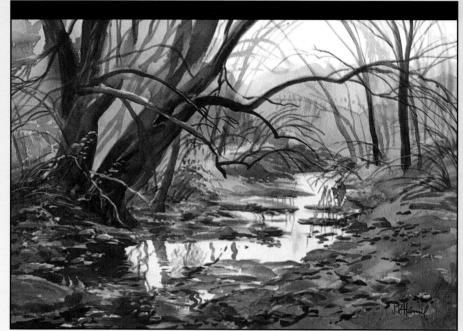

Contrast exists in tone and color, it exists in the primary colors, the complimentary colors, and also in textures, although watercolor paintings aren't renowned for texture. Nevertheless, some artists, like the German **Georg Grosz** or Spanish Martínez Lozano, paint watercolors that, due to their subject matter, technique and style, appear textured.

Martínez Lozano has even gone so far as to title one of his watercolors *Texture* (page 49, fig. 113), in which he effectively paints using colors straight from the tube, applying the paint thickly, with a palette knife, creating a richly textured surface.

But returning to the subject of contrast as a factor of Diversity let us look at the excellent watercolor by the North American artist **J. R. Hamil** (fig. 110), who I once met at a book fair in Frankfurt. This is a watercolor in which the white spaces are emphasized by using the paint to sketch round the white spaces of this pool or stream with its inlets and reflections. There is a rich contrast between the trees, stones and the reflections in the foreground, and the more diffused background, creating atmosphere and depth. The contrasts give a Diversity to the work, achieved whatsmore with an enviable restraint of color (note the two basic colors: black and sepia).

Consider this other magnificent example of Diversity created by the contrast of color, in Van Gogh's watercolor *Fishing boats on the beach of Saintes-Maries* (fig. 111, opposite page). We can see here how Van Gogh starts to build the image first by carefully sketching the boats in Chinese ink, continuing to paint in watercolor, searching out complimentary colors, contrasting the blue of the sky and the boats with the orange sand, and contrasting the red and purple of the boat in foreground with the green of the boat immediately behind it. A vivid contrast is set up between the

Fig. 110. James R. Hamil. *Central Park of the Pradera, East of Olathe (Kansas).* **Private collection. Courtesy of Southwind Press editorial. This is an excellent example of contrast between the trees, and all the details of the foreground seen against the light, a factor that enhances the white of the water and the mist or fog that discolors the middle ground and the background.**

Fig. 111 (opposite page). Van Gogh. *Fishing boats on the beach of Saintes-Maries.* **Private collection. From the time that Van Gogh associated with the Impressionist painters, many of his paintings represented the effects of contrast achieved by the juxtaposition of complimentary colors: the blue of the sky with the orange of the beach; the green and purple or magenta of the boats, etc.**

tones and colors of the image, the crucial element of Variety.

Look now, also, at the examples of Variety on the next page, achieved by the artist **Maurice Prendergast** (fig. 112) and the aforementioned Martínez Lozano, in his watercolor *Texture*, and Georg Grosz, in his watercolor *New York* (figs. 113 and 115 respectively). Variety can be achieved in a way that is evident in the oil painting by Van Gogh *Fishing boats near to Saintes-Maries* (fig. 114), where the thickness of the paint on the crests of the waves –yellowish in color due to the oxidation of the

color white– creates a Diversity or variety that catches the attention of the spectator.

Is that everything? Well, no. In the composition of the painting, as well as the unity and the variety, the law of the golden section, the compositional format, the contrast and the texture, take into consideration the rules or factors that determine and accentuate the depth or three dimensional qualities; factors that we are going to deal with right now in the following chapter.

111

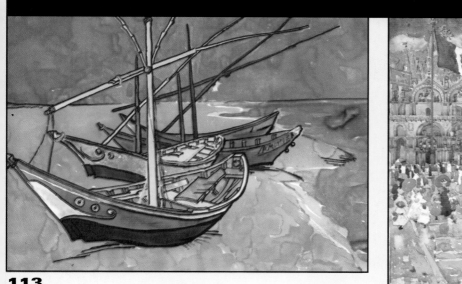

112

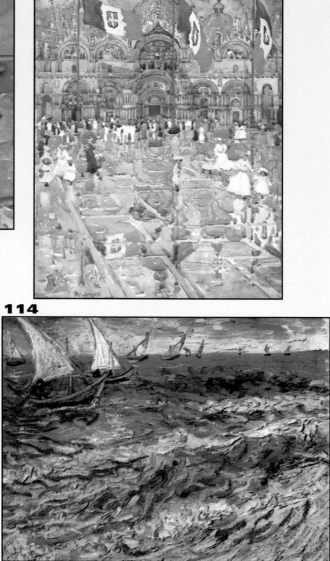

113

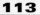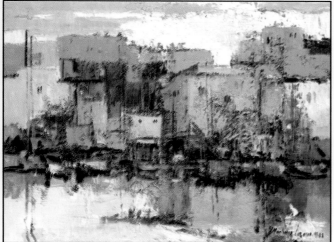

114

115

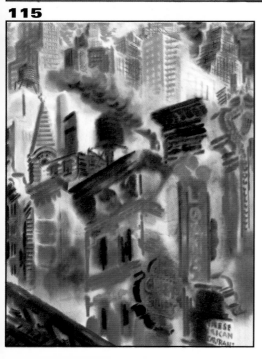

Fig. 112. Maurice Prendergast. *St Mark's Square, Venice*. Watercolor. Collection of Alice M. Kaplan. Prendergast, a North American painter well-known for his crowd scenes in watercolor, visited Venice on one of his trips to Europe and painted St Mark's Square a number of times. In the painting above you can see how various unpainted spaces have been left white, representing flags and clothes.

Fig. 113. Martínez Lozano. *Texture*. Private collection. Martínez Lozano is a great watercolor and oil painter. When he paints in oils and with a palette knife he frequently emphasizes effects and contrasts by applying thick layers of paint. It can be seen that on this occasion he has applied this technique to watercolor, creating these layers with a palette knife.

Fig. 114. Van Gogh. *Fishing boats near Saintes-Maries*. Pushkin Museum, Moscow. You can see how the *impasto* lends texture to the waves of this rough sea. Van Gough regularly used this *impasto* technique which emphasizes the dramatic qualities of his paintings.

Fig. 115. Georg Grosz. *New York*. Institute of Arts, Detroit. This is an Expressionist watercolor which has no texture, but due to its colorful forms and contrasts it is an excellent example of Variety that justifies its reproduction in this context, Variety of contrast and texture.

Volume, Contrast, Atmosphere and Perspective

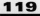

119

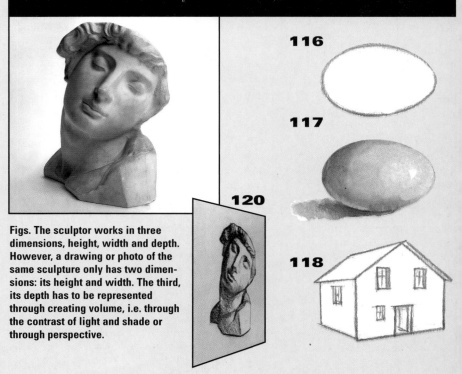

116

117

120

118

A line drawing of an egg without light or shadow isn't an egg: it is only a simple oval (fig. 116). For it to become an egg it needs to be painted using a play of light and shadows, or in other words, by applying color and volume (fig. 117). However, if you draw a house and draw your structure in perspective (fig. 118), using only lines, you represent not only the height and width, but also, thanks to perspective, the depth.

This is the problem, our problem: representing the depth. Sculptors work on their statues in three dimensions: the height, the width and the **depth** (figs. 119 and 120).

We however, the painters, the drawers, work in only two dimensions: the height and width of the paper or canvas. The depth, the third dimension, has to be represented with the volume and the perspective, as we have seen in the example of the egg and of the house.

Therefore, knowledge of these factors can help the artist emphasize and achieve this third dimension, this depth that gives character and veracity to drawings, pictures and watercolors. These factors are:

1. The volume, the contrast, the atmosphere and the perspective.
2. The inclusion of a foreground and the *coulisse* effect.
3. Achieving contrasts and painting with near and distant colors.

These factors, as well as obtaining the depth or third dimension in the painting, are determiners in the good composition of the scene developing the Unity within Variety. But let us look at the following examples of volume, contrast, atmosphere and perspective.

From the Renaissance to Impressionism, all the Great Masters of painting have developed volume to explain body forms and to represent depth. The same, applies painting with oil as with watercolor. Whether it be pain-

Figs. The sculptor works in three dimensions, height, width and depth. However, a drawing or photo of the same sculpture only has two dimensions: its height and width. The third, its depth has to be represented through creating volume, i.e. through the contrast of light and shade or through perspective.

ting a landscape, a still life, the figure or a portrait. **John Singer Sargent**, for example, in his portrait of an unknown man titled *A tramp* (fig. 121), models the head to create volume with a play of light and shadows.

The North American **Winslow Homer**,

in his watercolor *The pioneer* (fig. 122), gives us a good example illustrating an effect of contrast and atmosphere, with the black foreground contrasting with the nearly white middle ground and discolored mountain of the background.

121

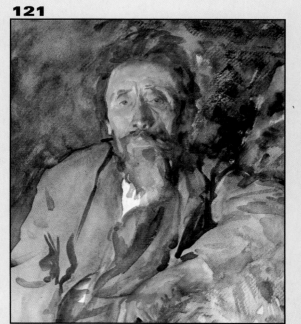

Figs. 116, 117 and 118 (above). To draw an egg, don't stop at its silhouette: Light and shadow need to be painted in order to give volume. However the line drawing of a house in perspective gives depth.

Fig. 121. John Singer Sargent. *A tramp*. Brooklyn Museum. In this watercolor portrait of an unknown man, Sargent values the play of light and shadow representing the volume, thus creating the third dimension.

Antonio López, in his *Gran Vía* of Madrid (private collection) (fig. 123), shows us a wide road viewed in perspective, without traffic or people, with a dramatic foreground composed of traffic signals and a background that loses color and form, thus creating distance and atmosphere.

In the painting *The road seen from the path of Sèvres* (fig. 124), by the Impressionist **Alfred Sisley**, there is a gradual decrease in the size of the row of trees wich accentuates parallel perspective.

In Van Gogh's *Garden* (fig.125), the perspective is created by the receding planes of flowers. The flowers are made up of dots of color that diminish in brightness and size as they reach into the distance. These devices are used to create an impression of depth, which introduces a third dimension into the picture and, furthermore, creates unity and variety within the composition.

122

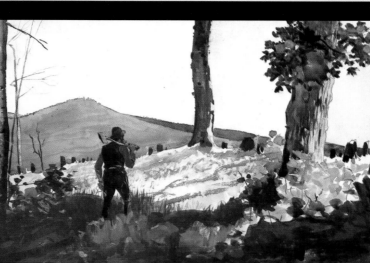

Fig. 122. Winslow Homer. _The pioneer_. Metropolitan Museum of Art, New York. Contrast and atmosphere are used to create depth. The almost black shadows in the foreground, along with the silhouette of the pioneer, contrast with the brighter colors of the middle ground. The atmospheric effects of distance are created by use of grayish colors for the mountain in the background.

123

124

125

Figs. 123, 124 and 125. Together with volume, contrast and atmosphere; perspective is the third, basic, factor in obtaining the third dimension, depth. These three paintings by Antonio López, Alfred Sisley and Vincent Van Gogh are perfect examples of the use of perspective as a factor in the representation of the third dimension.

Using the Foreground to Create Deph

One of the classic formulas used to represent depth involves the inclusion of a foreground detail that allows comparison between its size and the diminished size of the subject in the background. Let us use the figures 126 and 127 as examples of this. In the first of these images (fig. 126) we can see a mountain scene with a town, the town of Torla in the Pyrenees, with a featureless foreground. I took this photograph, and while taking it I looked behind me and saw a tree that could serve as the foreground, so I positioned myself in front of the tree and composed the image that you can see in figure 127. I created a foreground that determined the factor of depth and three dimension.

Look at the watercolor in figure 128, a practical example. It is a landscape that I painted outside Rupit, a town in the province of Barcelona, a landscape in which the depth is achieved by the group of trees on the right in the foreground.

But, what if there isn't a group of trees in the foreground? Then you have to resort to the practices of the 18th century English landscape artists. They created depth by painting some blurred, undefined shapes in the foreground of the picture, out of focus as today's photographer would say. The French painter **Rousseau** justified this device by saying: *"A spectator looking at a landscape doesn't see what he has at his feet"*.

So now you know: to achieve three dimensions, without a foreground, don't hesitate to use the formula of the English artists, paint an undefined foreground. I have done this in figure 129, and think that the final result is a good one.

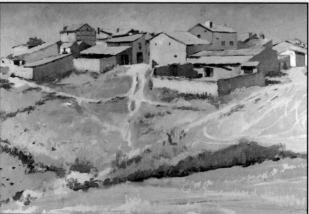

Figs. 126 and 127 (photographs by José M. Parramón). The photo in figure 127 was taken a few meters further back than that of figure 126, including the tree that provides the foreground, that, by visual comparison of distance and size, gives the spectator the impression of depth.

The *Coulisse* Effect

130

The French word *coulisse* is the same as the English word *wings*, the set or theatrical scenery. The French artist used this word to refer to the *superposition of planes*, as if they were the scenery in a theatre. The superposition of planes, like the set or scenery of a theatre, is yet another way to represent recession or three dimension.

You can see this effect in the landscape that I painted in the Pyrenees, next to the French border (fig. 130), in which the *coulisse* effect is created by the margins of the foreground, the row of country houses in the middle ground, the scenery of the nearest mountain and the mountains in the background (see the diagram in fig. 130A).

Notice also the *coulisse* effect in this study of the *Church of Saint-Germain-des-Prés* in Paris, where the superposition of the buildings promote the depth or three dimensions (figs. 131 and 131A).

131

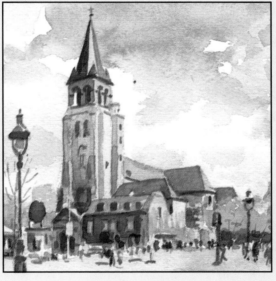

130A

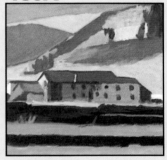

131A

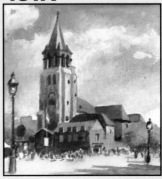

Fig. 128 (previous page). José M. Parramón. *Rupit landscape*. Private collection, Barcelona. The scene chosen in this landscape relates to the idea of creating depth with the help of the foreground, in this case the group of trees in the foreground, compared with the houses in the middle ground.

Fig. 129 (previous page). José M. Parramón. *Villa del Saz, Cuenca*. Artist's collection. If there isn't a highlighted foreground, or it is unsuitable, then you can compose a scene with a blurred or out of focus, undefined foreground, as I have done in this landscape.

Figs. 130 and 130A. José M. Parramón. *Mountain landscape*. Artist's collection. The *coulisse* effect is evident in this landscape from its superposition of planes, that give the idea of depth.

Figs. 131 and 131A. Jordi Segú. *Church of Saint-Germain-des-Prés, Paris*. Artist's collection. The structures of the various buildings, in this watercolor study, create the *coulisse* effect or superposition of planes, that emphasise the three dimension or idea of depth.

Achieving Contrasts

We have spoken about contrasts and atmosphere as factors in achieving three dimensions, but allow me now to highlight the two basic rules to bear in mind, when trying to achieve these factors:

1) **The foreground always needs to be brighter and more contrasted than the background.**

2) **At the point where the background disappears into the distance, it should lose definition and color, with a tendency towards blues, purples and grays.**

Gustave Caillebotte, one of the artists that participated in nearly all the Impressionist exhibitions, shows us in his painting *Parisian street in the rain,* a foreground with two figures painted with intense color; in this way creating strong contrast in relation to the pale colored building in the background. Look carefully at the way the color and contrast of the other figures fade as they move away from the foreground. Let's now look at what I call "achieving contrasts", in other words, invented contrasts that don't exist in the original subject matter, but which the artist creates and paints in order to emphasize and highlight specific shapes and forms, which in the words written by Leonardo da Vinci: *"The background against which the subject is set has to*

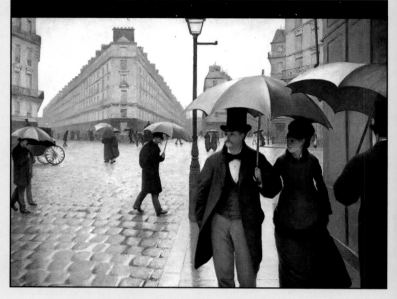

132

contrast it by falling into shadow where the subject is lit and being brighter behind the part of a subject in shadow". It's a rule that all the artists over the years have taken into account. Look, for example, at the still life by Paul Cézanne, *Pot with flowers on a table* (fig. 133), and see how Cézanne has created contrasts (fig. 133A).

Fig. 132. Gustave Caillebotte. *Parisian street in the rain*. **The Art Institute of Chicago. Caillebotte, the artist associated with the Impressionists, here shows us a particular drawing and painting technique, using a palette of toned down colors and a perfect use of contrast and atmosphere, shown in the foreground in the detailed forms of the figures, the intensity and definition is lost as you look towards the building in the background.**

Figs. 133 and 133A. Paul Cézanne. *Pot with flowers on a table*. **Musée d'Orsay, Paris. With the aim of emphasizing forms and highlighting contours, Cézanne, like all other artists, exaggerated contrast in his paintings. You can see by looking carefully at the points marked on the diagram of the painting in figure 133A.**

133

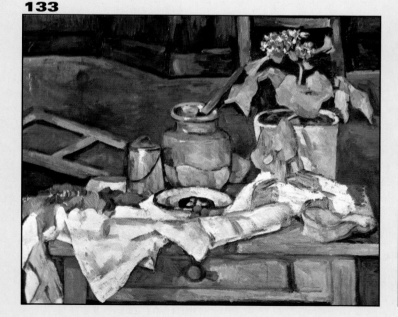

133A

Painting with Near and Distant Colors

The color yellow makes the subject appear to be nearer; and the color blue, farther.

There is a palette of near, middle and distant colors. This palette starts with the color yellow, followed next by orange, red, green, blue and then gray (fig. 134). Looking at figure 134 it's easy to see that yellow and orange are both near colors; red and green middle colors and blue and grey distant colors. This idea of near and distant colors was practiced by the Dutch landscape artists of the 16th and 17th centuries, who applied the Antwerp rules of: a yellow color for the foreground; green in the middle ground and blue in the background.

You can play with near and distant colors when composing a still life, however, it is difficult, though not impossible to do the same with a landscape. Give yourself a little leeway with the interpretation to get a bit closer to this ideal! That is exactly what Van Gogh did with his painting *Wheat field with cypresses* (fig. 135), and what I've done with the landscape photographed in figure 136; **Jordi Segú** and I interpreted it as you see in figure 137.

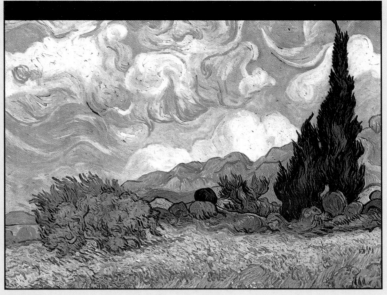

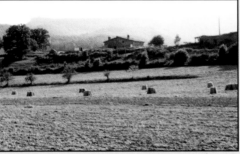

Fig. 135 (above). Van Gogh. *Wheat field with cypresses*. Rijksmuseum, Amsterdam. Van Gogh uses the formula of the Dutch landscape painters: yellow for the foreground; green for the middle ground, and blue for the background.

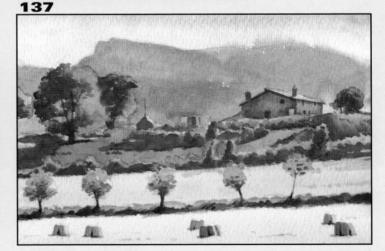

Fig. 134 (left). Scale of *near* and *distant* colors, separated by lines of warm and cool palettes of color.

Figs. 136 and 137. This landscape offers a colorfulness that permits the use of the theory of *near* and *distant* colors. The painter Jordi Segú and I have used this formula you can see the result in figure 137.

The Process of Interpretation

138

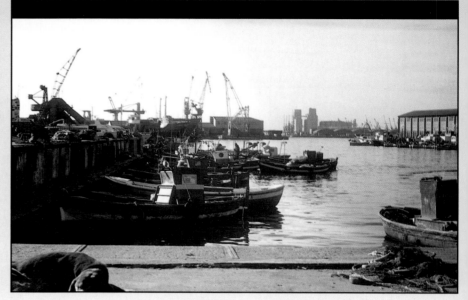

To interpret is to imagine. When we are before a subject which we wish to interpret in our own way, we have to imagine changes in forms and colors. The dictionary defines the term imagination as:

a) The ability to form mental images.
b) The ability to combine images.

Interpretation is intimately related to the image, because when we are in front of the subject that we are going to paint, in order that we don't just copy the subject but attempt to interpret it, we have to imagine a series of images. These images must be combined with the reality of the subject that we are painting, be it a landscape, seascape or still life, modifying and changing it, trying to create our own painting. Remember at this point the opinion of the great artists about the subject of watercolor painting *"as one sees it within oneself* –in the words of **Delacroix**–. *"The painters that copy a subject communicate the feeling of the spirit of nature to the spectator"*. And on the subject of imagination and interpretation, **Chagall** wrote *"We see nature as something ordinary; the artist has to see it and paint it as something extraordinary and wonderful"*. And the great **Picasso** reiterated the statements of Delacroix and Chagall when he said, *"The painter has to embue the painting with his own impressions and his own vision"*.
Taking into account the contents of these quotes, permit me to put forward some ideas, perhaps somewhat abstract, on the process of the imagination and fantasy of the artist when standing before his subject, with the intention of interpreting it.
Imagine that you are standing before the subject: a harbor (fig. 138). The first step of this process, as always, involves observing the subject for a while. Studying the possible ways of changing the forms, the palette of colors, accentuating contrasts and

atmosphere. Think about changing the viewpoint, seeing if a geometrical format is possible or if it's better *to lean slightly to the left or to the right*, improving the viewpoint and composition; think also in changing the format, painting a watercolor with a portrait format instead of that of a landscape. View the subject from above, and leave more space between the dockside in the foreground and the nearby group of boats, and between this group of boats and that of the middle and background. Naturally, in this detailed analysis you consider, also, the convenience of removing various forms, like the bulky shapes in the foreground and the boat to the right. Finally you analyze, first once and then again, the contrasts of the foreground, the atmosphere of the background, etc. and you start to form mental images, and combine images with *memories* –from this "mental archive of images and visual memories" that we all carry in our heads–, and you remember and imagine, for example, the painting by Van Gogh, *The harvesters*, with its yellow sky and blue background (fig. 139, opposite page), and imagine the sky and

the background of your harbor with these colors. You also remember that bay painted by Monet in Argeneuil at the end of an afternoon, with its palette of warm colors, that contrast with the nearly black foreground (fig. 140). And by associating your scene with this painting by Monet, images come to mind; of the harbor at Barcelona first thing in the morning, with the early sunlight and mist creating a warm and golden glow (fig. 141). You remember a painting with this same palette by the painter **Bonington**: a watercolor of the fish market in Bologna, Italy, with its warm, yellow tones, with dark figures and shapes in the foreground (fig. 142). Finally, you recall a photo, of a harbor, with its boats and their reflections on the water (fig. 143).

Fig. 138. *Fishing dock in Barcelona* (photograph by J. M. Parramón). Imagine that you are here on this dock seeing this image and suppose that you go through the process of interpretation explained in the text on this page and the images on page 57.

139

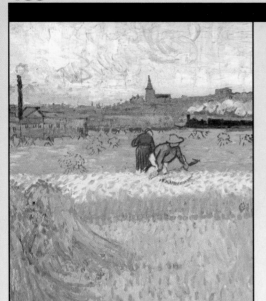

140

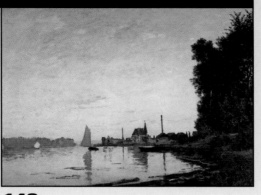

Fig. 139. Van Gogh. *The harvesters*. Rodin Museum, Paris.

Fig. 140. Claude Monet. *Argenteuil at the end of the afternoon*. Private collection.

Fig. 141. José M. Parramón. *Dawn in the fishing harbor*. Barcelona. Private collection.

142

Fig. 142. Richard Parkes Bonington. *Fish market, Bologna* (detail). New Haven C.T. Yale Centre for British Art.

Fig. 143. *Reflections on Bilbao dock*, Barcelona (photograph by J. M. Parramón).

141

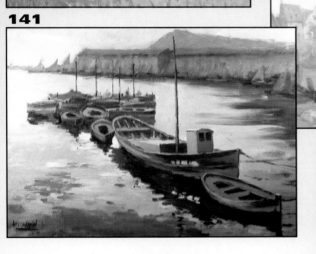

143

This way to remember, form and combine images, to "see" a subject in a different way to that which is given by reality, means that this place of priority is imagined by you. How? By combining what you see with the imagined and remembered, mentally working, studying possibilities, emphasizing, accentuating and, in a nutshell, venturing into the terrain of creativity, that I believe can be defined as **a new attitude towards something that we wish to change**. This is to say, a willingness to paint a painting that is different to reality, that can be translated, therefore, into that which has never been seen or thought of.

Thorez and the *Three Rules on the Art of Interpretation*

The French painter **André Thorez**, in his book *How to paint the landscape and the figure*, summed up in three words the art of interpretation:

<div align="center">

Exaggerate

Supress

Omit

</div>

Exaggerate, highlight, increase, intensify a color, the contrast of the foreground; the volume of that tree; darken the sky; highlight the ripples of the water.

Supress, soften, reduce the size of that tree, the width of the path, the color of the straw, the height of the mountains, the contrast of the background, the volume of the clouds, etc

Omit, eliminate, leave out, remove the electricity pylon, the truck in the street, the modern house in the background, the tarmac road, the tractor, the foliage of the foreground, the tables of the bar, etc

144

145

Figs. 144 and 145. This is the result of the process of interpretation studied on the pages 56 and 57, with the texts and corresponding images. See at the foot of figure 145, the original subject and the process of change that it has undergone, it has a blue and cool palette of color, whereas in the watercolor it has an inclination towards a warm palette; omitting the the details in the foreground and exaggerating the distance between the nearest boat and the dock wall, reflections nonexistent in the original subject have been added. But most importantly, is to have painted using a vertical format, enabling a more detailed representation of the boats and different planes of the painting.

The First Enemy: The Subject Matter

146

Paul Cézanne, the painter considered as the "father of modern art", had an idea about the art of interpretation, expressed, in the following words sent by his son Lucien to the writer **Léo Larguier**:

«Painting doesn't consist of the servile copying of the subject, but in the captivation of harmony between the numerous relationships and translating them into a vision of one's own, unveiling a new and original concept».

It is a perfect definition, because, in principle, everyone who paints –you, I– wants to create in their paintings this "vision of one's own, unveiling a new and original concept". In theory, you and I should think about taking this idea of Cézanne's literally.

Ah, but in practice... in front of the subject matter it is another story. The famous Post-Impressionist **Pierre Bonnard**, in an interview with the journalist **Angele Lamotte**, explained in the following experiences and failures when dealing with the art of interpretation:

"I tried to paint them –some roses– direct from life, with precision, but got carried away by the details... and found that I was drowning, that I wasn't going anywhere. I knew that I had lost that first impression that I had had, I couldn't regain my first impulse, the vision that had dazzled me, my point of entry. I reached the conclusion that the presence of the subject matter, the scene, is a hindrance for the painter while painting".

It is the same idea Delacroix expressed when he said: *"The subject matter keeps everything for itself, and leaves nothing for the painter".*

"An idea is always the starting point; the presence of the subject matter while working is but a temptation;

Fig. 146. Claude Monet. *Water-lilies* (detail). Orangerie, Tuileries Gardens, Paris. This is one of the panels of the water-lily series, on which Monet worked for over twenty years, painting aquatic plants, water-lilies and skies reflected in the water. This culmination of over two hundred and fifty paintings and nineteen panels (detail above), were give to the French State to decorate the two rooms of the Orangery in the Tuileries Gardens in Paris.

the artist runs the risk of letting himself be taken in by its direct, immediate appearance, forgetting his first impulse... and ending up accepting its overwhelming presence, painting the shadows that are in front of him or a detail that in the beginning didn't interest him".

Bonnard also spoke to Angele of Monet's fear of feeling dominated by the subject matter. Saying:

"Claude Monet painted in front of the subject matter for only ten minutes. Not giving the things (subject matter) time to empower him".

It could be that Monet painted for a quarter of an hour or twenty, and not just ten minutes, but this idea coincides with the fact that Monet painted various paintings at the same time. When he painted the *Cathedrals* of Rouen, he worked on nine canvases at the same time and, furthermore, it is known that he retouched his paintings in the studio, far from the subject matter.

On his lake at Giverny he worked for over twenty years, painting some two hundred and fifty paintings and nineteen panels, including this one in figure 146, which was given to the French State. It is also well known that, with the series of the lake at Giverny, Monet for quite some time, held back from giving the paintings to his art dealer Durand-Ruel, as they weren't completely finished and needed to be retouched.

What should you do so as not to be seduced by the mermaid's song, the subject matter? Pierre Bonnard answers this question in his interview with the journalist Angele Lamotte:

> **"By doing the same as Cézanne: when Cézanne was in front of the subject he had a firm idea of what he wanted to do, and only accepted from nature that which was in relation to his idea... accepting the things...exactly as they were in his conception".**

A way of working that provoked a lot of discussion, not only by Bonnard, but by other painters and writers too.

Figs. 147, 149 and 151 (bottom, opposite page). When I visited Venice, I painted two paintings and took some photos of the Grand Canal (fig. 149). Claude Monet painted this subject and when I arrived home, I looked in my books until I found these two examples of the *Grand Canal in Venice:* the first (fig. 147) in the San Francisco Museum of Fine Arts, and the second (fig. 151), in the Boston Museum of Fine Arts. Both paintings demonstrate an original conception of the subject, a result of a free and creative artistic interpretation.

147

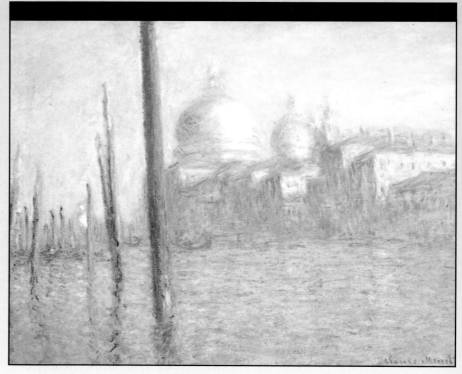

Fig. 148 (left). Claude Monet. *Gondole.* Museum of Fine Art, Nantes (France). Monet died in 1926, at the age of 86. When he was 68 he travelled to Venice and in one of his letters wrote: *"The moment has arrived to leave this unique light, I am saddened. I console myself by thinking about returning next year. What a shame that I didn't visit here when I was a younger! Here I have experienced delicious moments, nearly forgetting the old man that I am".*

148

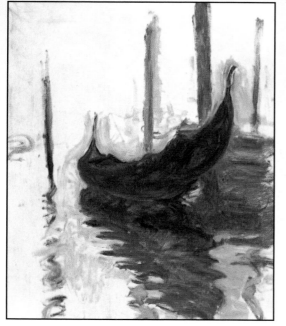

149

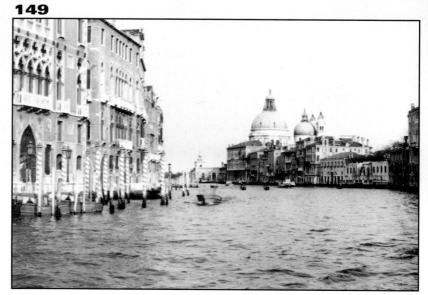

150

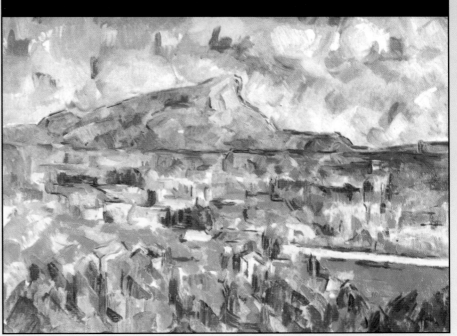

John Berger, the English painter, novelist, and critic, wrote in his book *The look of things*:

> **"The greatest heroism of Cézanne's self discipline consisted of his capacity to observe the painting that he was working on with the same attention and objectivity with which he studied the subject. It sounds very easy. As easy as walking on water".**

Imagine that Cézanne painted one of his landscapes (fig. 150), "looking at the subject intensely and fixedly for a few minutes –which is what those who had the opportunity to watch him paint said he did–, quickly turning his head to the canvas and painting only one touch of color, only one brushstroke", intending to create his idea, his conception, his painting and telling himself, again and again "as I see it... as I see it".

Fig. 150. Paul Cézanne. *Mountain Sainte-Victoire*. Collection of Mr. Mrs Carroll S. Tyson. Philadelphia. Cézanne painted this landscape somewhere between 1904 and 1906, towards the end of his life, Cézanne died in 1906. It was the time in which Cézanne had surpassed Impressionism and painted "with the firm idea of what he wanted to do, and only accepted from Nature that which was in relation to his ideas".
From then onwards he painted like a predecessor of the most advanced styles, of Expressionism, of Cubism, of modern art.

151

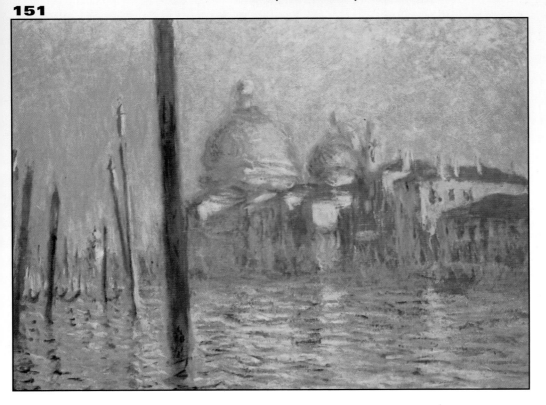

Fig. 152. On the following page you'll start practical exercises on the topics studied in this book: an exercise on the dry brush technique, two exercises in perspective, a harbor and an example of interpretation, finishing with painting a copy of the famous watercolor by Joseph Mallord William Turner, *Venice, San Giorgio from the Dogana*, an exercise that puts to the test your ability in the technique of wet on wet painting, a technique mastered expertly by Turner.

PRACTICAL
EXERCISES

So, we arrive at the last pages, the end of this volume, and at a series of practical exercises in which you will have the opportunity to practice the lessons given in the previous pages of this book, namely: the perspective of basic forms for example, with forms made by you that will be painted using dry brush technique; followed by an exercise, also on perspective, painting a village street in parallel perspective, and, still one more final exercise, to draw and paint an interior in oblique perspective. Next follows the painting of a harbor scene in the Costa Dorada; using a landscape as an exercise in interpretation, and, the exercise that I think is the most exciting one in the book: nothing less than painting a copy of the famous watercolor by Turner, executed in Venice in 1797, *San Giorgio from the Dogana.*

Painting Basic Forms with a Dry Brush (I)

153

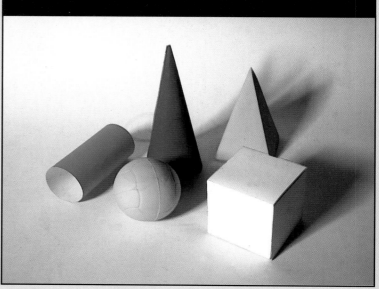

Figure 153. Look at the shapes in the adjacent figure. I made the forms myself, using white card for the cube and colored card for the pyramid, cone and cylinder. The sphere is a small rubber ball of approximately 6 cm in diameter; the cube is 6.5 cm in height and width. You can make these forms and buy the rubber ball or you can use the finished watercolor on page 67 as a model, it is larger than the photo in figure 153.

Figures 154 and 155. You are now going to practice painting using the dry brush technique; a technique that has various requirements, as much in materials as in true technique. The paper, for example, should be heavily textured –I have painted using Whatman paper, with a heavy grain–, so that, when passing the almost dry paintbrush loaded with thick paint, or, the again almost dry paintbrush but loaded with diluted paint. the color fixes itself to the ridges in paper's

154

155

156

grain, thus creating its own texture. It is necessary to work on test sheets of paper at the same time as painting the watercolor in order to dab and blot the brush (fig. 154). A roll of kitchen towel, similar absorbent paper or a rag is also necessary to pinch the brush and to clean it of color. The purpose of pinching the brush at certain moments is to facilitate the technique of the dry brush, it's best to squash the hairs of the brush giving them the shape of a fan as you can see in figure 155 on the previous page. With respect to the brush itself, I have worked the background using a fan shaped, synthetic haired brush, the hair of which being 2 cm in length and a round, number 12, sable haired brush. The forms I painted with a number 6 and a number 3, synthetic brush.

Figure 156 (opposite page). Let me remind you now of the two rules when painting with the dry brush technique, explained and illustrated in volume two of this collection, *Techniques & color*, on page 26, in which it states, that we work with two dry brush techniques; one, rubbing the paintbrush, almost dry, with a load of thick paint, and the other, also rubbing the almost dry paintbrush, but this time loaded with diluted paint, used on forms or areas for mid and light tones. Look again at the illustration (fig. 156).

Figure 157. So I begin. I draw the subject matter from life, on paper measuring 28 cm x 25.5 cm. As

157

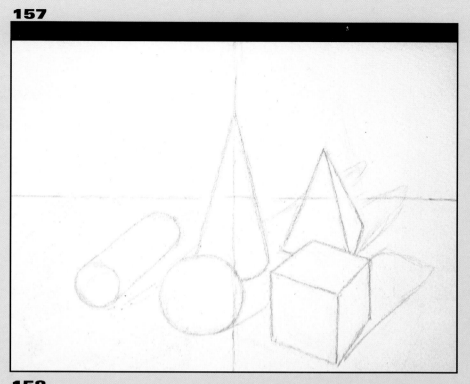

158

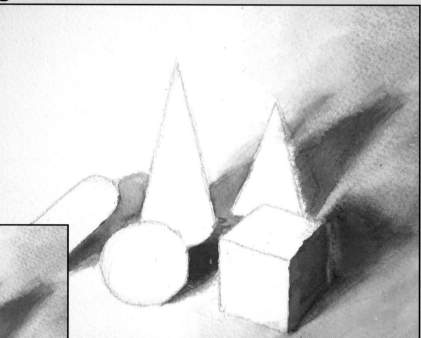

159

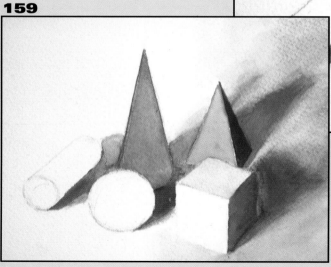

always, to simplify the calculation of the dimensions and proportions, I draw a cross in the center of the paper. Sketching a line drawing of the forms, without shadows, as they have to be painted in watercolor.

Painting Basic Forms with a Dry Brush (II)

Figure 158 (previous page). I start by painting the background on the right hand side, in which you can see shadows projected from the geometrical shapes, I paint with a mixture of Payne's gray, a little carmine, hardly any, and a touch of ochre. I don't worry about crossing the line of the shadow projected by the cube and the pyramid.

Figure 159 (previous page). I continue to paint, with Payne's gray and a little Prussian blue, the shadow on the top of the cube, and I paint the lighter area of the pyramid with dark yellow, ochre and the smallest touch of crimson. I continue with the cone, painting the first layer a mid tone ultramarine blue.

Figure 160. The rest of the background is now filled in with a graduated wash in mid tone for the smaller area, created by using an almost dry paintbrush loaded with heavily diluted paint, which, upon reaching the top of the cone, fades into white. I paint with Payne's gray and a very small amount of ochre, using a fan brush of synthetic hair, and painting the upper graduated area using the dry brush technique I add the color using a number 12, sable haired paintbrush.

Figure 161. I continue to paint the ball and the cylinder with flat, volumeless colors, dark yellow and cadmium red; a number 3, synthetic haired paintbrush. Next, I paint the shadow on the cone to create the volume of this geometric shape. First I apply a thick, dense layer, practically without any water, of ultramarine blue. Due to the thickness of the paint, I get to the part where I have to shade and create volume, I have to dab the brush a number of times on the test

160

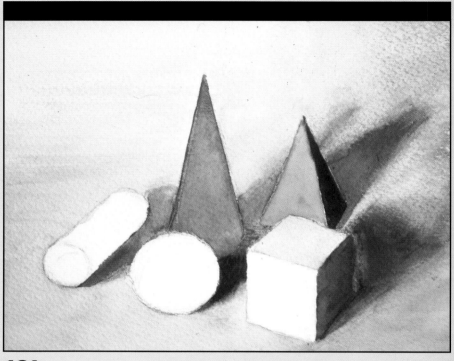

161

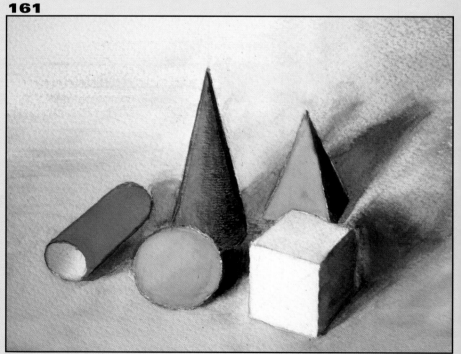

162

paper and absorbent kitchen paper or rag, pinching the head of hairs to achieve a fan shape and obtaining, using the dry brush technique, a shaded area giving form to the cone. I create and strengthen volume by painting with a layer of shading, in black superimposed onto the color blue, and this part is finished.

Figure 162. I finish this exercise of basic forms by painting the shadows on the ball and cylinder using dry brush technique. Dark umber, ultramarine blue and crimson for the ball's shadow, and crimson with a touch of Prussian blue for the cylinder's shadow. Using a number 3, synthetic hair paintbrush, with thick paint dabbed lightly on the test paper and absorbent kitchen paper or rag.

How do you feel? How did it go? I hope that everything went well and that you practice this technique which can by used when painting any subject matter, in particular, still lifes, like the one illustrated on the introduction page to this book.

Painting an Urban Landscape in Parallel Perspective

Figure 163. This is the subject: a street in a village, some 25 kilometers from Barcelona, called San Cugat del Vallés, famous for its historical Roman Monastery built in the 11th century, which has a rose window 7 m in diameter, that you can see in the the background of this photograph, next to the bell tower of the Monastery. If it wasn't for the Monastery of San Cugat, this street would have no great interest, neither picturesque nor artistic, but it is a good subject for an exercise in drawing and painting in parallel perspective. A perspective that, as you already know, has only one vanishing point.

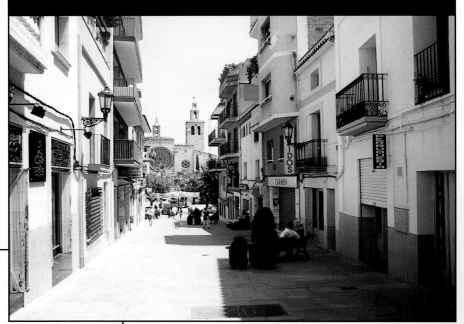

163

164

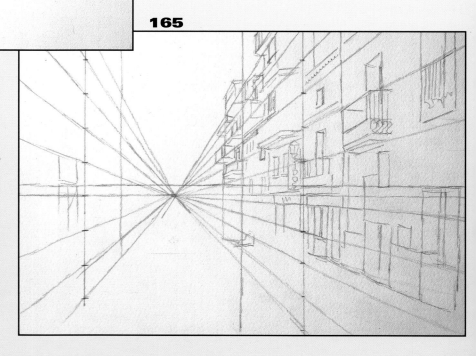

165

Figure 164. I begin the drawing, as always, by tracing, first, vertical and horizontal lines that cross the surface, thus making it easier to outline the structure, dimensions and proportions of the scene. Looking straight ahead, I judge by eye the height of the horizon line, that falls almost in the middle of the drawing. I study the scene and draw in a diagonal line at the base of the houses on the left, up to the vanishing point sitting on the horizon line, and I locate the line from the houses' roofs to the vanishing point. I start to sketch the diagonals formed by further vanishing point lines.

166

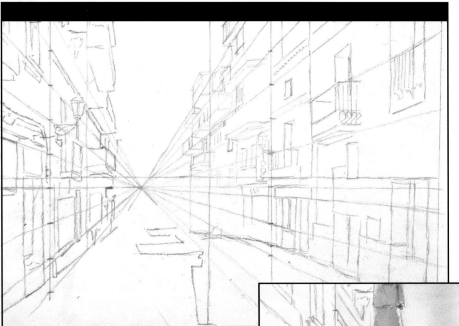

with water, creating a pale cream for the walls on the left side, the same colors but with a touch of ultramarine blue for the walls on the right side, bearing in mind that this is the side which is in the shade. Prussian blue with a little cadmium red and ochre for the color of the shadow projected and the base of the house on the right of the foreground. As the watercolor progresses, the colors are developed, the cream color is overpainted with different veils of color which ease gently towards deeper tones, redder, deeper yellow or deeper blue.

167

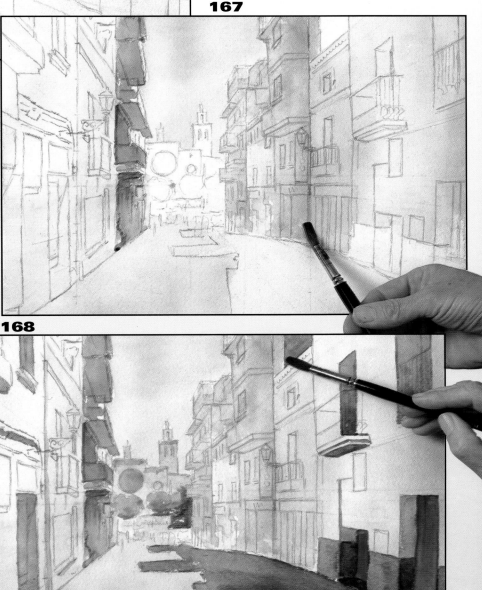

168

Figures 165 and 166 (fig. 165 on the previous page). I now draw guide lines, from the vanishing point, on both sides of the street and start to sketch openings, doors, windows and balconies on the right side. I continue with the doors and windows on the left side and draw in the lines that define the shadow on the ground on the right side of the street.

Figures 167 and 168. In the background, I draw in the Monastery of San Cugat and rub out the vanishing point guide lines, leaving the lines which draw the street and its details, these being the doors, windows, balconies, etc. Using a wash of ultramarine and Prussian blue with a small touch of crimson, I paint the sky. Next, I paint a series of washes, the background, the walls on both sides of the street, painting a pale color, which I adapt to the color of each detail. I move on to the shadow projected by the houses on the right side of the street and paint in some of the doors and windows on both sides. Finally, I give the Monastery and the trees in the background their first layer of color. Here, in short, are the colors that I have used: for the walls, including those of the Monastery, generally ochre and crimson, heavily diluted

Painting an Urban Landscape in Parallel Perspective (II

Figures 169, 170 and 171. We are progressing to the final stage of the picture on the next page. I paint a base color for the shadows of the doors and windows on the lateral walls, made up of ultramarine blue, with a little Payne's gray and an even smaller amount of crimson. I paint the doors of the foreground a reddish color using a mixture of ochre and crimson with a touch of blue (fig. 169). Next, I strengthen the color of the shadow on the ground and the dark verticals of the doors with Payne's gray and a little ultramarine blue (fig. 170). I continue by painting more openings, bars and balconies. Emphasising on the left, the row of balconies at the far end, first painted with crimson, ochre and Prussian blue, heavily diluted with water, to achieve a mid tone, which I now intensify using the same mix of colors. I draw and paint some small figures at the end of the street, next to the square in front of the Monastery. I finish by applying thin layers or veils of paint to vary the color of the walls, applying washes of ochre, sepia, blue, etc. (fig. 171).

169

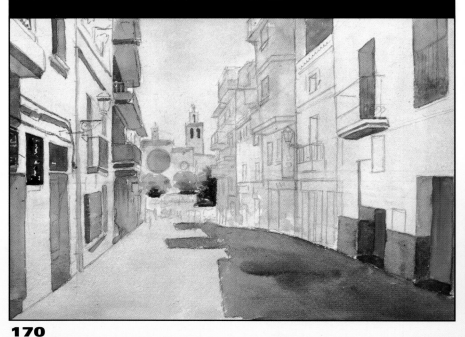

170

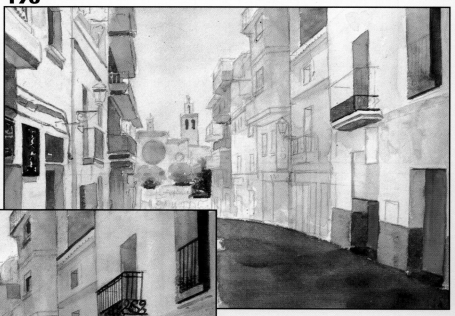

171

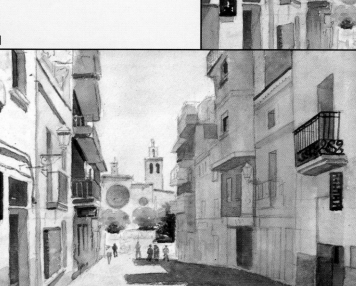

172

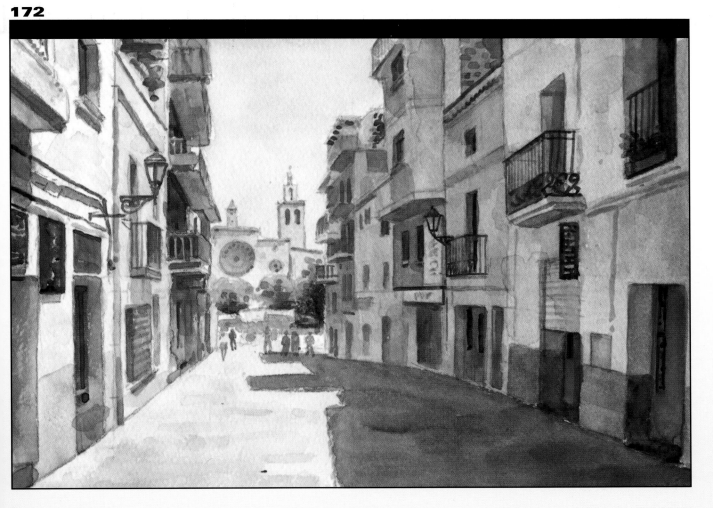

Figure 172. And here is the result of the exercise in parallel perspective; a conclusion, as you can see, by comparing the image in figure 172 with that of the previous image in figure 171. Further paint has been applied and a few more details have been added, the following passage explains the process.

Hardly any further work is needed on the foreground houses on the left, I darken the shadow on the wall and the shadow cast by the window recess a little, I use the same color (Prussian blue with a touch of carmine) on the walls surrounding the doorways in the foreground. Again, with the same color I emphasise the line dividing the first house from the second in the foreground and work on the details such as the shaded area above with its tiny spots of red which represent flowers. I continue by adding detail to the street lamp and the balcony, and finish the rather undefined window next to the door. the houses further off on the left with their reddish balconies are already practically finished in figure 171. I now deepen the color of the tone in the lower part where you can make out the doors and windows of the building.

In the background, in the area of the Monastery, I emphasize the form and color of the trees and paint, with a spot of blue-gray, the lower part of this area.

On all the walls of houses on the right I start by painting a general wash in Prussian blue with a touch of crimson, with the intention of accentuating the color of the shadow of all of these houses.

Afterwards, I work on the house in the background, creating and emphasizing some details, for example, the balconies and windows in the upper section of the building. I paint the bricks red on the upper part of the third house in the middle ground, giving a red finish to the door of the same house. I then paint a series of lines representing the sliding door of the house in the foreground, next to the blue panelling, I highlight the color of the balcony opening in the foreground, intensifying the color of the latticed window in the foreground... And I'm going to leave it here, without adding any more details and finishing touches which are nevertheless what brings alive this watercolor of a street painted in parallel perspective.

Painting an Interior in Oblique Perspective (I)

173

Figure 173. Now let's consider this sitting room, in oblique perspective with two vanishing points, consisting of geometrical shapes such as cubes; the sofa, chair, tables and chimney and cylinders; the lampshades etc. and the tiled floor.

Figure 174. To draw the tiled floor in oblique perspective you need a 20 x 40 cm piece of paper so that the vanishing points on either side can be included. Following the diagram in figure 174, start by drawing the horizon line (HL), that should measure at least 32 cm in length. Place on the horizon line, about 19 cm from its right end, the measuring point (MP). Draw the right angle A -'A; the vertical A should measure exactly 10.5 cm, and the horizontal 'A, 18.5 cm. Now mark vanishing point number 1, on the right side, 15 cm from the measuring point, and trace the vanishing line B, from the vertex of the right angle (C), to the vanishing point number 1. On the left, and 13 cm from the measuring point, mark vanishing point number 2, and trace the vanishing point number 2 lines, D and E. Now draw a diagonal from the measuring point, that, passing through the vertex F, ends on the horizontal line 'A, that of the right angle. This horizontal line will be the ground line (GL). Lastly, divide this ground line (GL) into 12 parts.

Figure 174 A. Use this trick to make it easier, draw a diagonal (G), which forms an acute angle with the line that you want to divide and mark this line at 1cm intervals, which, with the help of a set square and ruler can be transferred to the line to be divided.

Figure 175. On the left of the horizon line, exactly 2.2 cm from the measuring point, mark another point that will be the diagonal's vanishing line (DVL). Draw a diagonal from this point, to the vertex of the right angle (C). This diagonal, where it crosses with the vanishing point line D, allows us to draw the vanishing point line H, to the vanishing point number 1, with which we have outlined the rectangle of the tiled floor. Let us now draw, in oblique perspective, the tiles of the tiled floor. For this you should trace a series of twelve lines, from the divisions in the ground line, to the measuring point. But, as you can see in the diagram, figure 175, it isn't necessary that they reach the MP; it will be sufficient that they reach line B. Let's move on to the final steps.

Figure 176. From points A,B,C,D, etc. on the vanishing line B, trace diagonal lines to the vanishing point number 2. Where these lines cross the DVP line points M,N,O,P, etc. are created. From these points trace diagonal lines to vanishing point number 1. Now draw in the tiled area in oblique perspective.

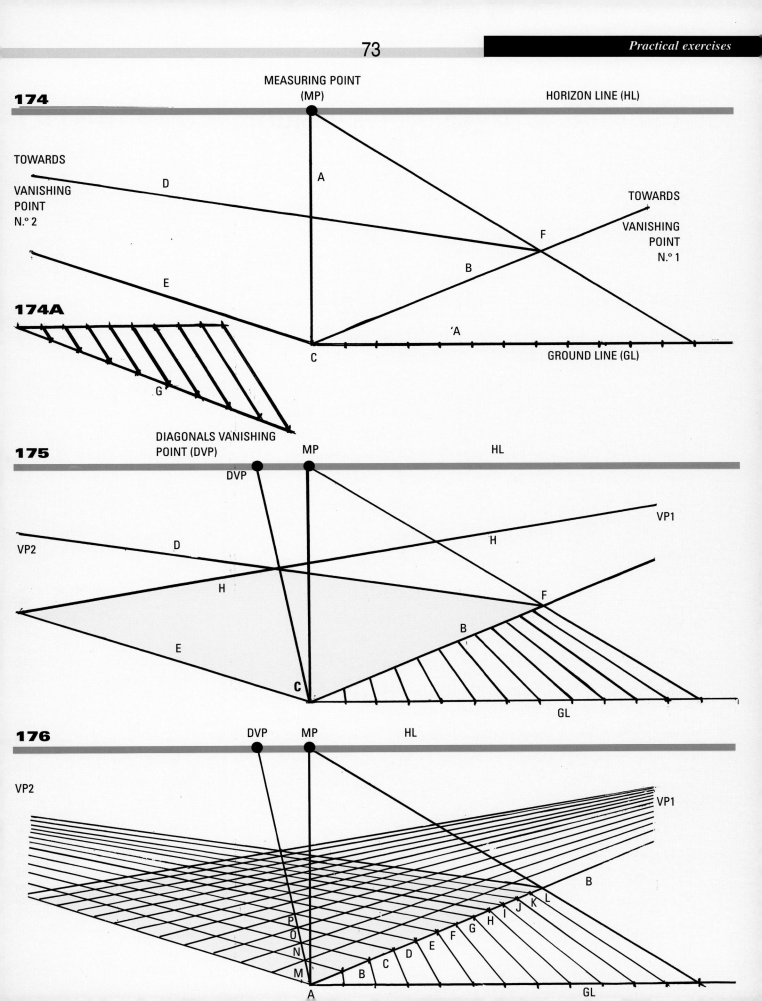

174

MEASURING POINT
(MP)

HORIZON LINE (HL)

TOWARDS

VANISHING
POINT
N.° 2

D

A

TOWARDS

VANISHING
POINT
N.° 1

F

B

E

'A

C

GROUND LINE (GL)

174A

G

DIAGONALS VANISHING
POINT (DVP)

175

DVP

MP

HL

VP2

VP1

D

H

H

F

E

B

C

GL

176

DVP

MP

HL

VP2

VP1

B

K L

P

I J

O

H

N

F G

M

E

B C D

A

GL

Painting an Interior in Oblique Perspective (II)

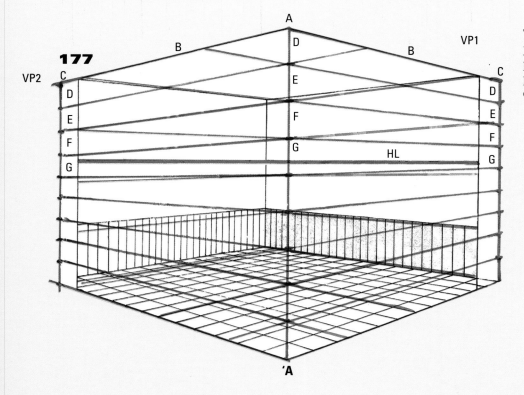

To make all this easier I suggest that you stick a pin into each vanishing point, you can rest your ruler on the pin which will make tracing the lines easier.

Figure 177. On page 27, figures 52 and 53 of this book, I have explained how to use guide lines when the vanishing points are "off the edges of the paper". You used a page with vanishing points in the last exercise to create the tiled floor, alternatively, you can apply the same system of guide lines as that used on page 27. In order to do this simply trace the vertical line A-'A from the edge of the mosaic ('A) to the topmost corner of the ceiling (A), 4.5 cm from the horizon line. Enclose the cube by drawing diagonals B and B towards the vanishing points 1 and 2 from point A. Then divide the vertical line A-'A into nine parts, trace the verticals C and C to enclose both sides of the cube, dividing these two verticals into nine parts and finish by joining points D, E ,F, G, etc., to establish your guidelines. You can now add in the furniture, starting with the wooden skirting board.

179

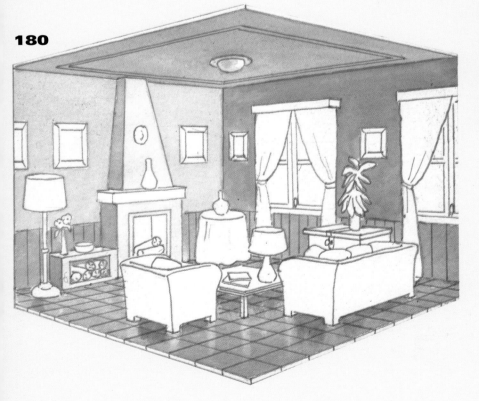

Figures 178 and 179. (Figure 178 on the previous page.) As you already know, in 1436, the architect, Leon Battista Alberti, invented a formula for drawing tiles in parallel perspective; thanks to this formula, artists of the time positioned furniture and other objects by using guidelines given by the tiled floor. So, you can now do the same to position and draw the furniture and objects in this sitting room. Start by sketching with a B or 2B pencil (fig. 178, previous page) and finishing up with a line drawing like the drawing in figure 179.

180

Figure 180. Finally, we start to paint. First, the ceiling, the tiles, the walls, the skirting boards, i.e., the biggest areas. In all of these areas a warm palette of color predominates: ochre, raw Sienna for and the tiled floor, a pale cobalt blue, with a touch of cadmium red and an even smaller amount of crimson, diluted with lots of water.

Painting an Interior in Oblique Perspective (III)

Figures 181 and 182. The shapes and colors of the room now come alive with the combination of the red-pink table, the sepia of the table on the right at the back of the room, the contrast of dark tones on the chimney and the wood store, and above all, the cobalt blue of the armchair and sofa (fig.181). And in the finalized image the objects have gained volume, contrasts between the wall and the skirting board, the windows and the frame, between the watery washes of ultramarine blue and ochre, which reflect the light entering from the windows. The darkest colors are the reddish-pink of the chest, the blue-gray shadows projected by the table in the corner the shadows at the back of the chimney and the woodstore. See how the frames and pictures are given volume by the

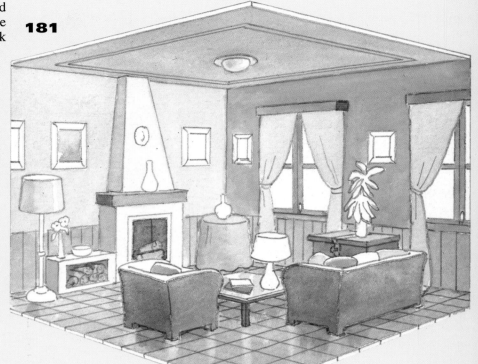

181

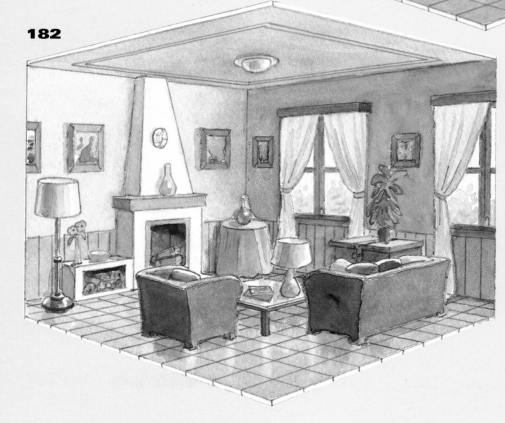

182

subtle shadows they cast, and how the green of the plant contrasts with the chest which is in shadow on the right. The colors of the pots, the lampshades and the combination of colors of the cushions on the sofa are all shaded to give shape and variety, the colors and shapes of the cushions create a pleasing combination in harmony with the ultramarine blue and Payne's gray of the sofa. The combination of the shapes and colors makes this more than just a simple study of oblique perspective (fig. 182).

Painting a Harbor Scene (I)

183

Figure 183. My good friend Gaspar Romero is going to paint a watercolor of the harbor at L'Ametlla, on the Costa Dorada, close to the city of Tarragona. We have picked a good day, a sunny day which brings out the qualities and effects of the light and shadow, captured in the adjacent photograph, which I took while Gaspar Romero prepared his easel and board, by sticking the paper to it with masking tape. But look, I took the photograph using a vertical format, thinking that Gaspar Romero would agree with the composition that I had imagined (fig. 183A), but he decided to paint the watercolor using a horizontal composition, as you can see in the scene on the next page in figure 185. "*You see –Gaspar said to me–, the composition that you imagined gives a very normal sky, almost monotonous, a gradually fading blue, without a cloud in the sky. Another aspect being that the foreground features the jetty, which I also don't like; I am thinking of omitting it. Also –he says continuing his argument–, the horizontal format is more suitable for painting a harbor scene. At the top, I will cut, a few centimeters off the building next to archway and, at the bottom, close to the keels of the boats in the foreground, I will omit the harbor area or jetty*".

Figure 184. Here is a photo of José Gaspar Romero painting this harbor at L'Ametlla, in the province of Tarragona. Notice the position of the board, tilted almost vertically.

184

183A

Painting a Harbor Scene (II)

185

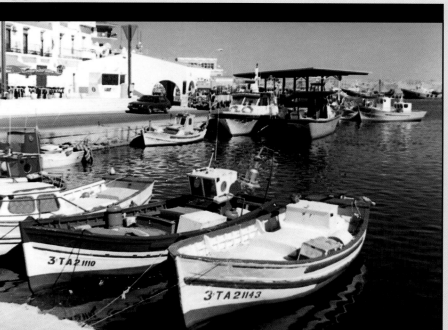

Figure 185. This is the scene as Gaspar Romero wishes to interpret it. As you can see, in choosing a landscape format Gaspar omits the houses on the left, cutting the image above this flat roof, above the two blue and white boats in the middle ground.

Figure 186. Gaspar Romero draws the scene with his usual precision and detail with a perfect decisiveness in the calculation of the dimensions and proportions, as you can see in this image. Notice the careful construction of all the details of the scene, from the boats in the foreground, and middle ground, to the details in the background.

Figure 187. He goes on to paint the shadows and shaded areas, with a very pale ultramarine blue wash.

"Why paint these shadows with pale blue, Gaspar?". I asked Gaspar Romero, who answered: "Well, at the moment the sunlight is advancing on the shadows that I have initially painted. But, as I work on the watercolor, and more so by the time I have finished it, the position of the sun will have changed and with this the shapes of the shadows too. By painting the shadows first, I immobilise the forms and can't fall into subsequent errors. And, as for painting these shadows with a pale blue color, you already know that the color blue is always present in the composition of the color of shadows, so...".

186

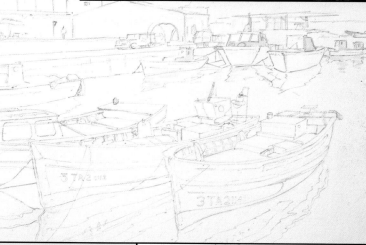

187

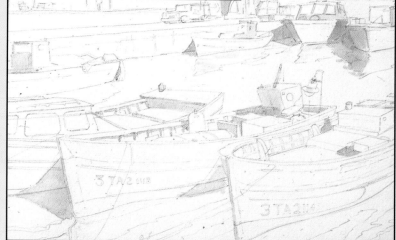

Figure 188 (next page). He starts to paint, using sky blue with a touch of carmine, to obtain the section of the sky. He goes on to paint the background. Gaspar Romero always starts by painting the backgrounds of his paintings, painting from the top of the canvas and working down-

188

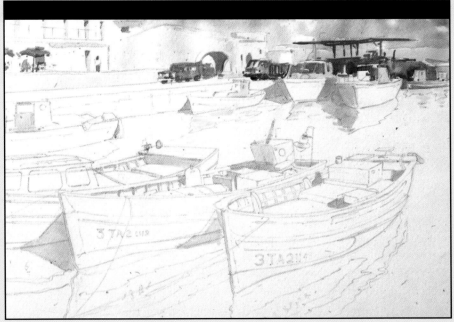

wards, with a fair amount of detail in farthest forms and with a tendency or predominance towards the color ultramarine blue, to create the atmosphere, of distance, with three dimensions.

Figure 189. Now he paints the middle ground, with the white and blue boats, and the boat on the left of the foreground. Painting the two larger boats in sky blue and the trimmings, in cadmium red. He also paints the cabins of the white boat and the shapes on the blue boat.

Figure 190. He now paints the sea, covering the white of the paper which, because of its brightness, has had an effect on how other colors of the painting look. This problem which we know as simultaneous contrast is resolved when the wash is applied to the

189

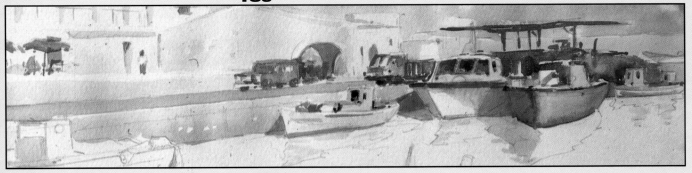

190

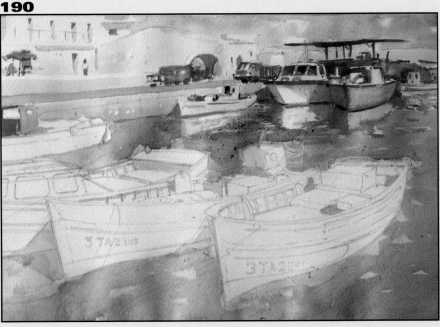

sea. Gaspar Romero starts by wetting the surface of the area with a number 12 sable brush, and then goes on to add a wash of ultramarine blue with a hint of cobalt green. Now he goes on to create white spaces for the reflections of the boats in the middle ground, by absorbing the watery wash of color using a brush which has been squeezed dry. Next, he paints zigzag forms, with sky blue, to represent the shapes reflected on the sea by the boats of the mid ground. He continues to paint the sea in general, with ultramarine blue and cobalt green, leaving small areas of the previous paler blue exposed, depicting the swell or surge of the water. Finally, he re-enhances the tone of the awning in the background.

Painting a Harbor Scene (III)

Figure 191. Deciding on ultramarine blue for the cabin, he differentiates the areas in the shade from the highlighted parts. Next he paints the details on top of the boat and the red stripe at the waterline. He moves on to the third boat in the line, painting the three cabin windows with a raw Sienna wash first, then adding a second wash of dark umber after the first has dried, to create intense shading in this area. He then adds the three blue lines and the brown line on the hull and the red stripe on the waterline, continuing to paint the shadows and a few details of the deck with ultramarine blue, with sky blue on the beam of the stern. Leaving it as it is, he moves onto the second boat, he paints the trimming of the gunwale a pale cobalt blue, and the cabin at the back with pale and dark cobalt blue.

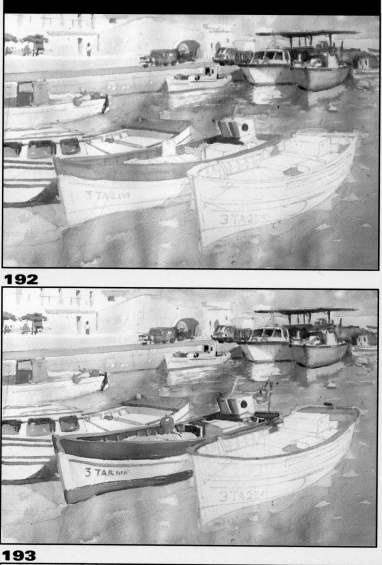

191

192

Figure 192. He now defines the shapes and colors of the second boat, he starts by applying dark cobalt blue for the trimming of the gunwale. He paints the objects that can be seen inside the boat, including a bottle of butane gas (cadmium red and a little yellow), he paints the red trimming at the base of the boat and the inscription on the side, sketching and forming the fishing lamp on the stern of this second boat, and with raw Sienna he begins painting the gunwale of the boat in the foreground.

Figure 193. Now moving on to the first boat in the line, the nearest. First he paints details on the sides of the boat and its deck with a cobalt blue wash. With raw Sienna, strengthened with burnt umber, he adds details to the stern of the boat. He uses the same color but with a little ultramarine.

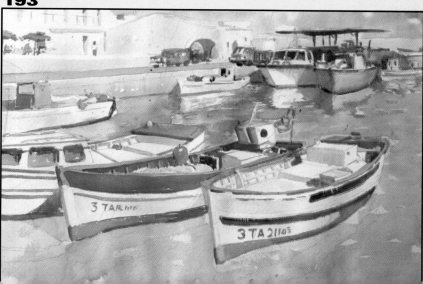

193

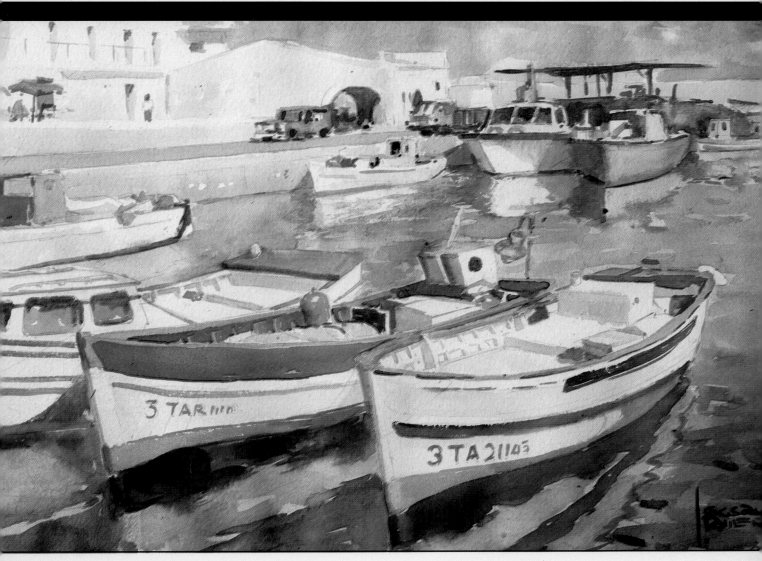

Figure 194. Gaspar Romero finishes this watercolor by painting the sea in the foreground. Using a color mixed from raw umber and ultramarine blue, he starts with the dark reflections of the boats on the water. He continues with ultramarine blue, painting the reflections next to the boat in the foreground, and with the same blue, lightly toned down with raw Sienna, he paints the reflections next to the second and third boat.

As you can see in the final stage, this is no ordinary blue watercolor wash, especially not in the foreground, next to the first boat. Gaspar Romero has painted this area of the sea, and the sea in general, with irregular patterns depicting the shine and shimmer of the swell of the water. Finally, Gaspar Romero has applied a paler blueish gray color, which reflects the white of the boats, always maintaining this irregularity of the patterns reflected in the sea. He retouches the color intensifying, for example, the color of the sky resulting in sharpening the outline of the building on the left of the background; he also intensifes the color of the lamp on the second boat in the foreground; darkening, with the same cobalt blue, the lines on the side of the first boat and the square blocks on its deck...

–Don't touch it Gaspar. It's fine as it is– I tell him.

He leaves it as it is, and signs it.

A Personal Interpretation of a Landscape (I)

195

Figure 195. I was in Cuenca, the plains of Castilla, and I stopped the car before a landscape that seemed to me to be appropriate to paint. I climbed a slight hill and from there I took this photograph. I set up my easel with the board and a piece of Fontenay de Canson watercolor paper, with a heavy grain. At first I placed the board and the paper in horizontal position, in exact accordance with the landscape. But I didn't start to paint, I spent a good while just looking, observing the scene and the possibilities it offered in terms of interpretation, imagining other landscapes, other images, other colors and formats.

Figures 196 and 197. With this process of thought and interpretation, I imagined that I was in a place higher up, viewing the landscape from above, in a perspective that allowed me to separate the ground into planes. I changed, therefore, the horizontal position of the board and paper, placing them vertically, imagining that I would stretch the countryside and would conceive, finally, of a landscape with an interpretation and composition like the one you can see in adjacent diagrams.

196

197

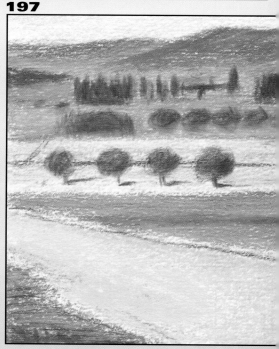

Figure 198 (next page). With this concept in mind I drew an outline, using a 4B pencil, of the landscape, starting by tracing the cross in the center to make the calculation of the dimensions and proportions easier. Even though in this case, thanks to the divisions of the meadows or fields of the given landscape scene, the dimensions and proportions were relatively easy. Given also that the forms of the trees, meadows and areas of land weren't a true copy of the subject matter, but were the fruit of my imagination, the reference to the subject wasn't of such great importance.

Arriving at the straw bales in the foreground, I exaggerated their size and arrangement and placed them in a way that accentuated the perspective of the foreground. However, in spite of that, and the changes made from interpretation, if you compare the drawing with the photograph, checking the spaces, the meadows, the cypresses and the trees, you will see that they are practically the same.

198

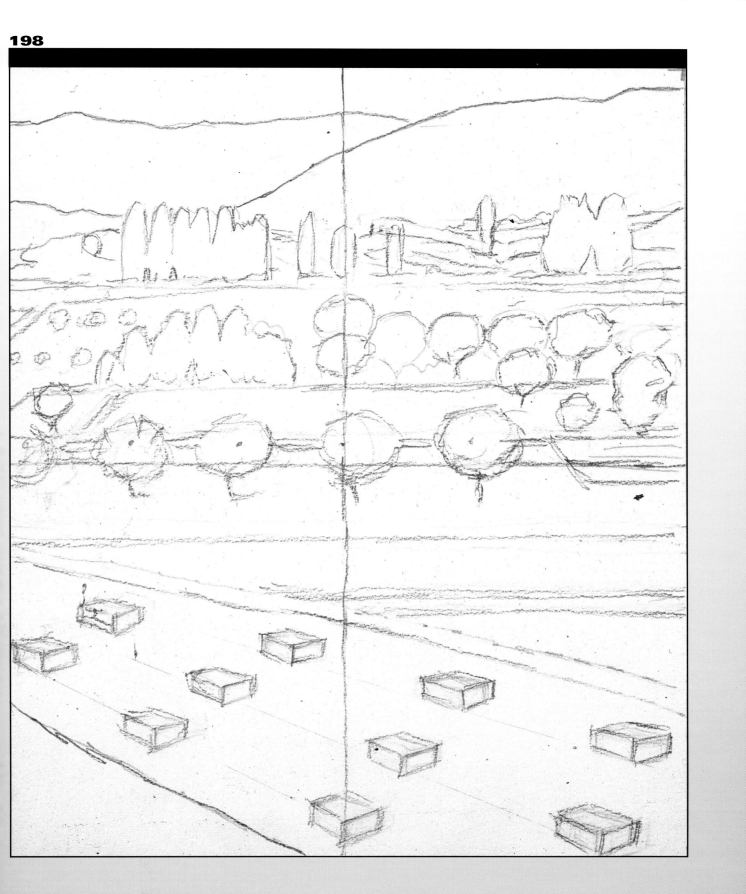

A Personal Interpretation of a Landscape (II)

Figure 199. I started to paint the sky with a carmine wash. With the same color but mixed with a touch of Prussian blue, I painted the side and smaller part of the mountains in the background, with a tendency towards pink that I imagined at the foot of these mountains. As you can see, the paint fades to white, leaving the white of the top of the mountains to paint them later with the color blue.

Figure 200. Next I painted the blue of the mountains, which I interpreted a lot darker than the blue of the mountains in the original scene. The blue of these mountains is made from a mixture of ultramarine blue with a little burnt Sienna. While painting these mountains in the background the words of advice written by the French painter Camille Corot, came to mind: *"You have to paint from top to bottom, step-by-step, in the most complete way possible and in the first attempt"*. Corot goes on to say, that painting like this is more spontaneous, fresher, without trifling details that spoil the finish of the foreground.

Figure 201. Next I resolved the background of cypresses and meadows, guided more by my imagination than what I could see in the scene in front of me, to contrast attempting the cypresses and trees in the background with the mountains.

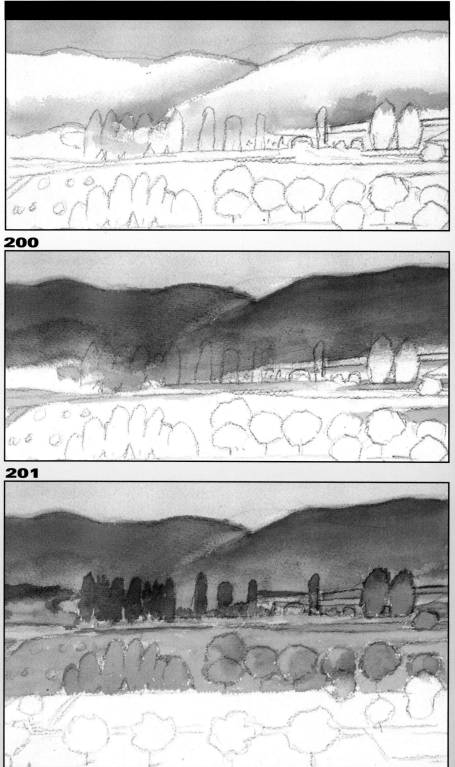

199

200

201

202

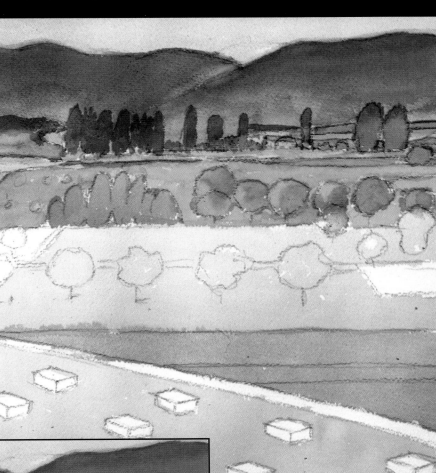

Figure 202. In the previous figure, having started painting the background I sketched in the colors of the strip of grassland and the trees, mainly concerned with covering the white paper.

I continued this way, covering the white of the paper so as to avoid the problems caused by simultaneous contrasts, remembering the rule which says that colors and tones are altered by the colors that juxtapose them, especially when they are next to a strongly opposing color (the white of the paper in this case). Note the little patches that I have left unpainted in the middle ground of the picture and the straw bales that are untouched in the foreground.

Figure 203. Next I intensified the color of the cypresses and trees in the background trying to achieve the maximum contrast between this middle ground and the background, the mountains, remembering Cézanne's ideas, that you and all those who paint with watercolor should bear in mind as a basic rule. With this in mind

203

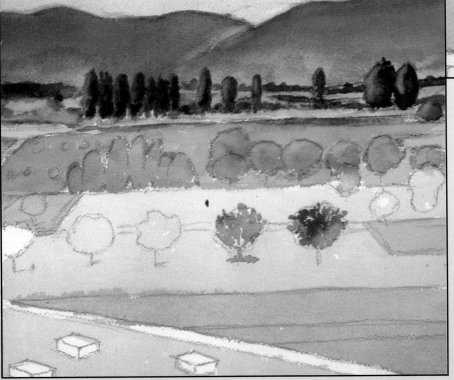

Cézanne wrote:

"One could say that PAINTING is all about CONTRAST".

It is evident that in order for the cypresses and other trees in the background to stand out, their color must be intensified so that they contrast more dramatically with the mountains. This is achieved by using emerald green and alizarin crimson to obtain a green that is almost black.

Afterwards I started the color and form of these four or five isolated trees in the middle ground.

A Personal Interpretation of a Landscape (III)

204

Figure 204. Continuing with Corot's principle of painting from top bottom, all in one go, I painted the row of cypresses and trees in the middle ground, imagining and including a few trees painted in autumnal colors, to add diversity to the colors and forms. In general, I painted the cypresses and the trees in permanent green and ochre for the lighter areas, and emerald green with a touch of Prussian blue in some cases, ochre and crimson for the parts in the shade.

Figure 205. I painted the color and texture of the grass and the two green triangles in the middle ground, painting on top of the previous layer of lighter green, a few touches of dark green, mixed from permanent green with a small amount of carmine to darken it. With these few touches I

205

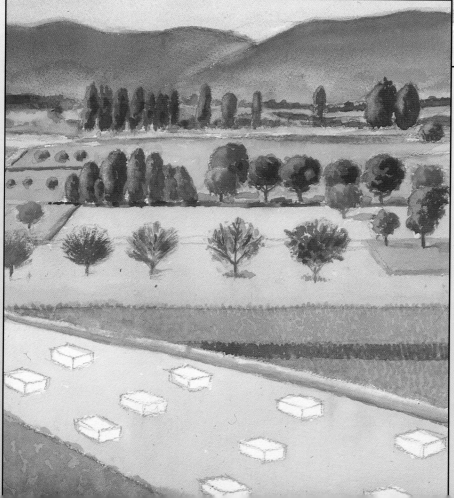

produced the texture of the grass. I painted the darker edges of the triangle in the middle ground, and its bordering edge with ochre, Payne's gray, with an abundance of water.

Figure 206 (next page). And this is my finished *interpretation* of this landscape.
So, to finish off I painted the bales of straw: the top with a wash of very pale ochre, one side with ochre and the other side, that which is shaded, like the Sienna of the projected shadow, the surrounding earth in a raw Sienna color, leaving small light patches where the wisps of straw catch the sunlight.

206

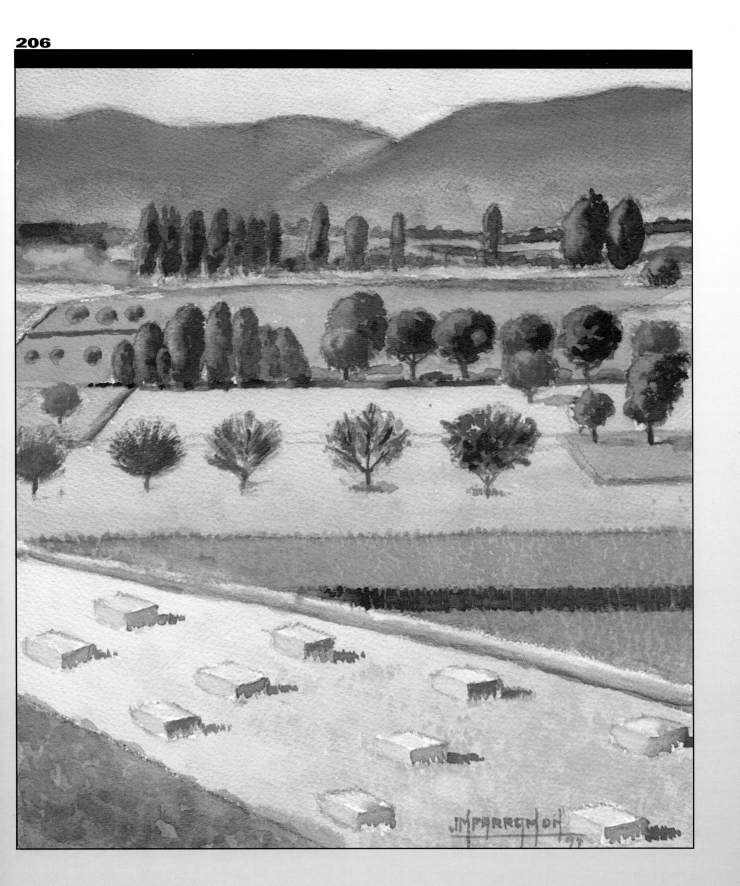

Painting a Copy of a Turner Watercolor (I)

And as the final exercise of the book, I invite you to paint a copy of the famous Joseph Mallord William Turner watercolor, *Venice, San Giorgio from the Dogana*.

Figure 207. The original Turner watercolor, on exhibition at The British Museum, London, measures exactly 28.7 cm x 22.4 cm, but you will be working on a slightly larger scale, 36,5 cm x 28.2 cm. This is due to museum's rules which state that *"the reproduction is obliged to be of different dimensions to those of the original"*.

Allow me now to give a brief commentary on how Turner painted and in particular how I think he painted this famous watercolor.

Turner's colors:

Cadmium yellow medium	**Raw Sienna**
Cadmium red	**Madder carmine**
Emerald green	**Sepia**
Ultramarine blue	**Ivory black**

The sky and the sea
First Turner dampened the paper with water and then painted, on wet, a wash of black mixed with water, that he merged in the center with an ochre-yellow color, diluting this hue by toning it down with water and merging it with gray in the sea, painting the reflections of the buildings of San Giorgio.

The buildings and the church of San Giorgio
To paint the church of San Giorgio and the buildings by its side, Turner painted first a general wash with the gray-pink color of the façade of the building, leaving the illuminated areas of the building on the left and the forms on the right. He waited until this gray-pink background color had dried and, continuing, with a mixture of black-gray, a little ultramarine and plenty of water, he painted the tower, the turret and the roofs of the buildings on the right.

The boats and reflection
Turner continued by painting the boats on the right with yellow ochre –made up of yellow and raw Sienna–– adding the shapes onto a gray background. Interestingly enough these boats are not reflected in the water. You may wonder whether he should have painted more details and used a wider range of colors thus spoiling the luminosity of the water? I think not. The beauty and the craftsmanship of this watercolor lies in the combination of its luminosity and the simplicity of the format, Turner's masterly interpretation cannot be improved upon.

207

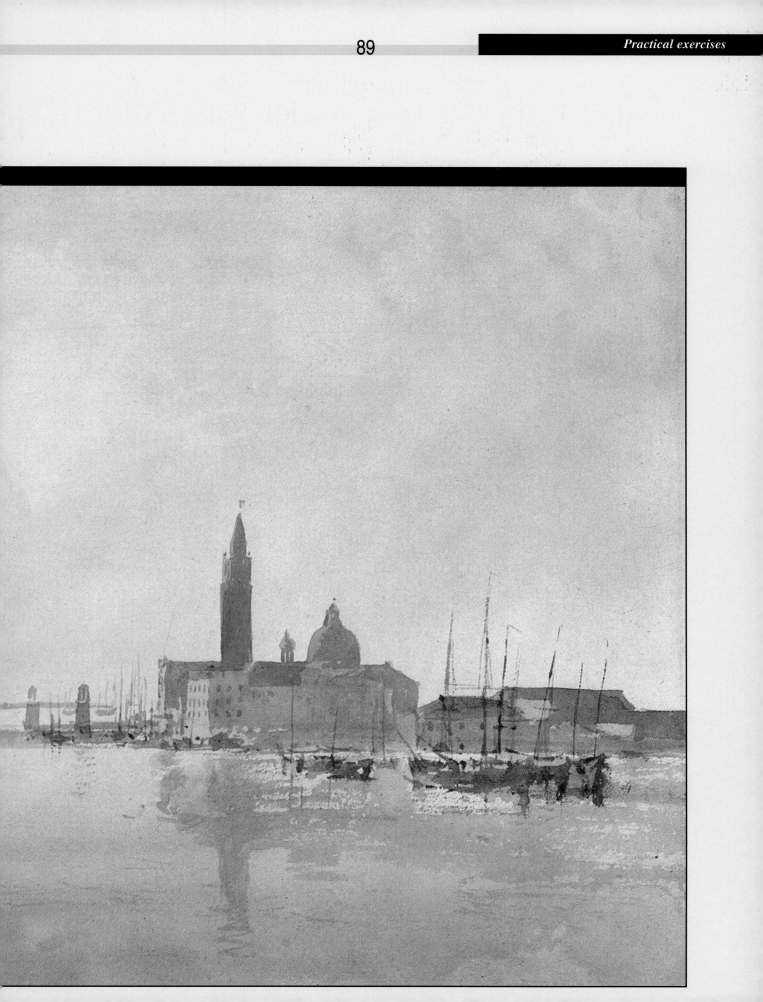

Painting a Copy of a Turner Watercolor (II)

208

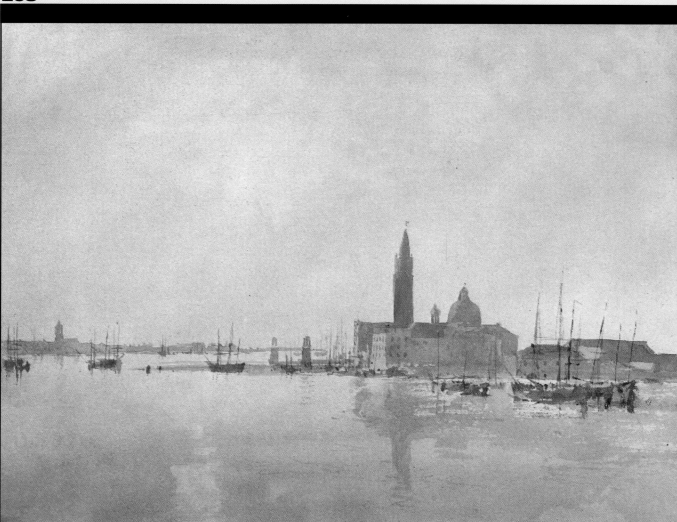

Figure 208. As you will find out for yourself, painting a copy of this Turner watercolor is no easy task. It requires great attention and careful work, without haste or impatience. I suggest that you follow this guide step-by- step, point for point, phase by phase, with the original reproduction of Turner's watercolor in front of you, feeling confident that in the end the success will outweigh your efforts by far.

Figure 209. Let us start by numbering the materials that we are going to work with, figure 209 of this page: **1. Paper**, a sheet of Whatman, medium textured watercolor paper (I have used this particular paper maker, but Fontenay de Canson, Arches, Fabriano or other quality watercolor paper with a medium texture may also be used). The paper size should be 36.5 cm x 28.2 cm; a size somewhat

209

larger yet in proportion to the size of the original watercolor by Turner (28.7 cm x 22.4 cm). **2. Palette box with an assortment of colors. 3. Paintbrushes**, a fan brush of synthetic hair (can be sable) with a tip of hair 2 cm wide, number 3 and number 6 paint brushes, both synthetic and two sable brushes, a number 9 and a number 12. **4. Pencils** B and 2B and a putty eraser. **5. Flask of water. 6. Long ruler and set square. 7. Paper towels. 8. Roll of brown tape. 9. Sponge.**

Now we begin. Well, not quite: first we have to wet the paper and mount it to the board using strips of brown tape, following the process explained on page 25 of the book *Material & techniques*, in this collection. A process which basically consists of cutting the piece of paper having first added a centimeter and a half more to its height and width (38 cm x 29.7 cm). Wet the paper under the tap and place it on the drawing board, stretching both sides, cut the strips of brown tape and stick the paper to the drawing board, leaving it in a horizontal position to dry, ready for the next day, providing you with a flat and taut paper that will resist the wetness of the watercolor, eliminating warping and wrinkles.

Figures 210, 211 and 212. Now, with the paper ready we can start with the drawing. I begin, as is my ritual, by tracing a cross, so I can calculate the dimensions and proportions more easily. Using a B pencil I start drawing. Once the sketch is completed, I rub it out, leaving only a light reference, and re-draw and highlight using a 2B pencil. It is important to use a sharp pencil in order to obtain a well defined drawing and it is crucial to make an exact copy of the original, as you can see in these figures.

210

211

212

Painting a Copy of a Turner Watercolor (III)

213

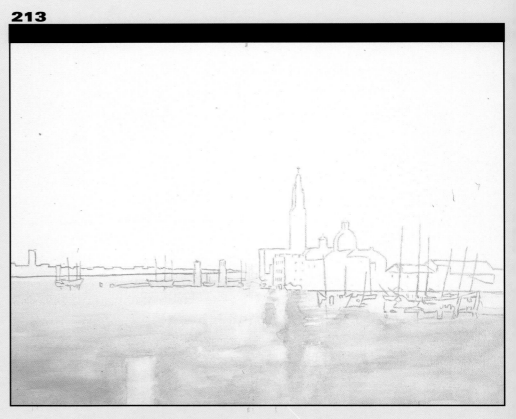

Figure 213. I start the water-color by dampening all of the paper with general wash of very pale ochre, so pale that it is barely visible. I use the synthetic, 2 cm, fan paint brush for this watercolor wash. I wait a few minutes for the wash to begin to dry, now I can paint on a damp but not wet surface, that allows for some definition even though shapes are some-what blurred, without any great definition. While the paper is drying, I mix together a medium gray color, made from Payne's gray with a lit-tle ochre, to warm the cold-ness of the Payne's gray. It is important that you prepare and have on the palette an ample amount of color, so that you don't have to remix colors. With the same fan paint brush I paint –and make it quick!– the shapes that appear on the water, leaving areaslight, but carefully copying the gray shapes of the reflection of the bell tower and the small and large patches of light. Some of these light tones I achieved by rubbing the fanned paint brush, reabsorbing the watery paint. I also use a paper towel, folding it in four pressing harder or lighter, to accentuate or reduce absorption.

And so we arrive at the most difficult part of this Turner watercolor: painting the colors and the tones of the sky, in which Turner achieved a per-fect fusion and harmony between the color ochre-yellow in the center and the warm gray of the structures and upper part of the sky.

Figure 214 (next page). But let us work section by section: first waiting for the forms and gray reflections of the water in the foreground to dry. (and here, a hair dryer can be very useful). When these shapes and reflections are dry, start in the same way as before, to dampen the area of the sky, the entire sky, to the horizon, the docks and the part of the sea, toning down with water, diluting and merging this yellow-ochre color to a medium intensity, with the area of grays and reflections in the middle and foreground of the sea. Apply this yellow-ochre color of medium inten-sity with the same 2 cm, synthetic, fanned paint brush and we continue working wet on wet. Next pick up a number 12, sable paint brush.

You have to work quickly now, keep at it! I prepare a more intense ochre and, painting wet on wet, I apply it in

214

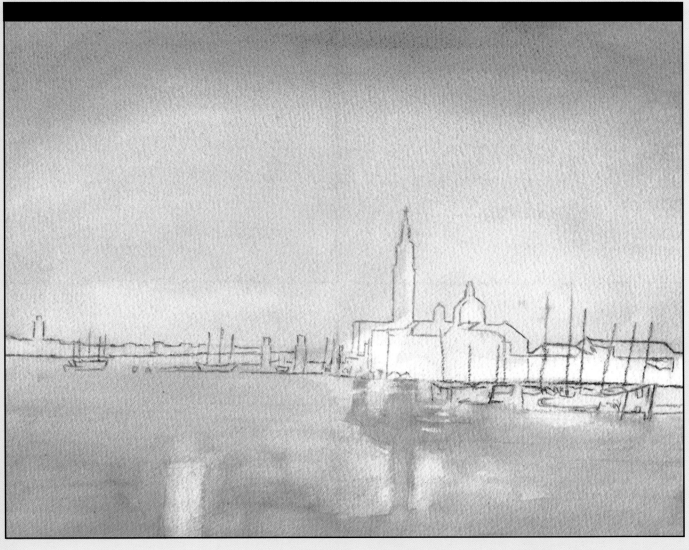

the center of the sky. I clean the brush, squeezing it so that it is nearly dry and dilute the ochre tone first, in the upper corners and then downward, to the sea. Faster! I prepare on another space on the palette a mixture of Payne's gray and a little ochre. With this mixture I paint a band of color, from one side to the other, on

the upper part of the sky; I clean the brush, rubbing it a little –quickly, quickly!– and I merge, tone down and dilute this gray band of color from the top until it merges this warm gray color with the mass of ochre in the center. And that is it! Time to leave the first section; now I have to retouch and harmonize by

using a slight blotting of the paint brush, or paper towel, or dipping the brush in paint –always wet on wet–, to resolve any small imbalance, any noticeable little intense or pale spots. But, I remind you, that if it can't be resolved on the first attempt, it's best to leave it.

Painting a Copy of a Turner Watercolor (IV)

215

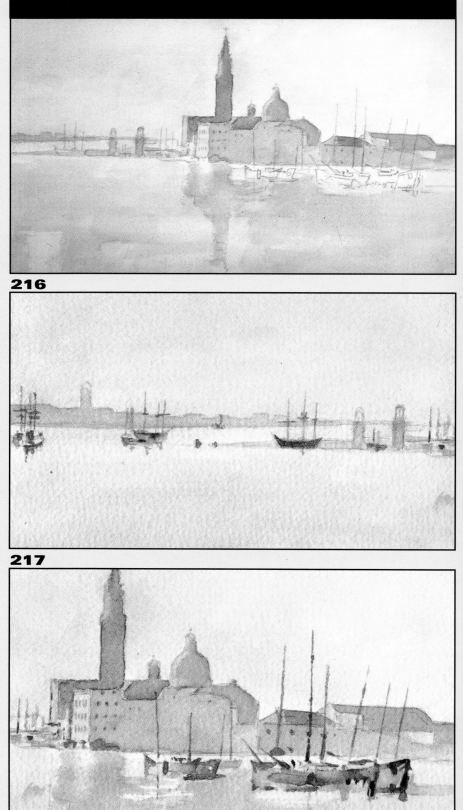

Figure 215. Turner probably painted with only one layer of color, without additional veils or layers, getting the different colors and hues right first time. But I, we, have to apply two or three veils or layers to get the tones of the church of San Giorgio and the buildings beside it, a mixture of ultramarine blue, a little Payne's gray and a very small amount of crimson or cadmium red for the pinkness of the buildings, in order to get it right. Test again and again on a test sheet, and on the paper on which you are painting this copy of the watercolor, with a second or third layer if necessary, adjusting hues and contrasts –don't forget to use contrasting colors and shapes– taking into account, for example, that to brighten the lightest part, the side of the pink building, you should darken the blue-gray-red of the right side. First, I paint the pinkish light areas of the bell tower and the cupola, which face the light. I also use a paper towel, blotting certain areas each time I think I have overdone the intensity of a particular color.

Figure 216. I continue by painting the docks and the boats on the left, with a number 3 synthetic brush, using the colors ultramarine blue and Prussian blue mixed with a little Payne's gray in order to give a slightly grayish effect, applying planes of even color, for the edges of the docks. Use ultramarine blue, Payne's gray and a little cadmium red to obtain a neutral black for the boats, the hulls and the masts where cross beams and sails are.

Figure 217. I continue working with a synthetic number 3 brush, and add the finishing touches to the vessels on the right. To help with the mixing of these colors I use a thicker paintbrush, a number 6 to mix the color in the metal palette of the paintbox, then I use the thinner number 3 brush to paint the details.

216

217

95

218

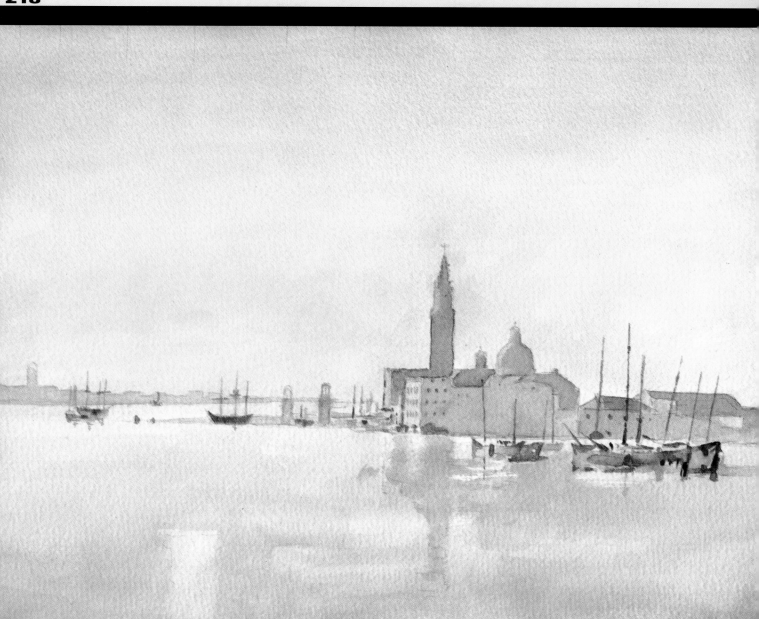

I start to paint the boats with a preliminary layer of ochre weakened with water, leaving unpainted spaces to emphasize the lighter patches. I continue to paint, still with a number 3 synthetic brush, the darker shapes with ultramarine blue, Payne's gray, and cadmium red. With these colors, by varying the tones with water I overpaint the darkest areas, contrast them with the mid tones and light grays, and add another layer over parts of the ochre wash. Finally I

painted the boats' masts.
As you can see, it's a time consuming, systematic task which can be summed up in a quote by **Michellangelo** who said that the key to success in a drawing or painting is that "*you have to draw and copy it all slavishly*".

Figure 218. I finish by looking over the work and retouching small details, opening white spaces with a utility knife and the eraser, and remo-

ving or softening the remains of the pencil sketching, by rubbing firmly over some of the details and lighter areas where the reflections are in the foreground. You can see the finished work above.

Acknowledgements

The author is grateful for the help and collaboration of the following people, organizations and enterprises in the publication of this book: The Catalonian Watercolorist Association for the courtesy of allowing the publication of various watercolors; the Orofoto studio for their work in the reproduction of materials and the step-by-step watercolor photographs; Manel Ú-beda of the company Novasis for his help in the publication and production of the photocomposition and the photo mechanics of this book and the artist José Gaspar Romero for the step-by-step painting of a watercolor produced specifically for this book.